AROUND WHITCHURCH & MARKET DRAYTON

DAVID TRUMPER & RAY FARLOW

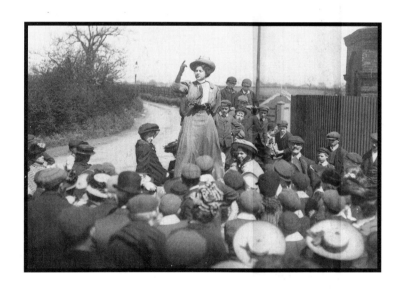

The History Press

To the memory of my son-in-law
Andrew Radford
A fellow historian and a loving family man
1975–2008

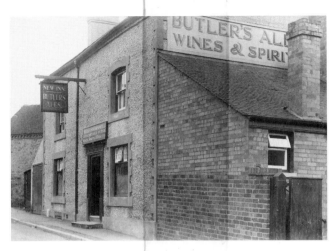

Stafford Road, Newport, *c.* 1920. The board over the front door reads 'William Cornmell Licensed Retailer of Beer, Wines, Spirits & Tobacco'. The New Inn was licensed before 1815 and in the 1896 census it was owned by Charles Eley, a brewer from Stafford, and occupied by Herbert Frost. The inn had four rooms on both floors and stabling for twelve horses. It was reported that the house needed cleaning and lime-washing and the stable needed a new cratch and lime-washing. In 1900 a charge against the landlord for permitting drunkenness was dismissed, while another charge for selling drink to a drunken person was withdrawn.

Title page photograph: The Foundry, Whitchurch, May 1908. In the spring of 1908 three suffragettes from the Women's Social and Political Union arrived in Whitchurch and held three meetings to speak for the cause of votes for women. The meetings were held outdoors, one by the wharf and two outside the foundry. The speaker is Gladice Keevil who addressed a large and fairly sympathetic crowd. She was accompanied by Elsie Howey and Miss Douglas-Smith who spoke at the other meetings. On the reverse of the postcard Lell writes to Margaret Sewart in Yorkshire, 'What do you think of this for a lady speaker? Mr Morris heard her. He says she speaks very well.' In 1918 married women gained the vote but it was another ten years before all women over twenty-one were given the right.

First published 2010

The History Press
The Mill, Brimscombe Port
Stroud, Gloucestershire, GL5 2QG
www.thehistorypress.co.uk

British Library Cataloguing in Publication Data.
A catalogue record for this book is available from the British Library.

ISBN 978 0 7509 4671 1

Typesetting and origination by The History Press
Printed in Great Britain
Manufacturing managed by Jellyfish Print Solutions Ltd

CONTENTS

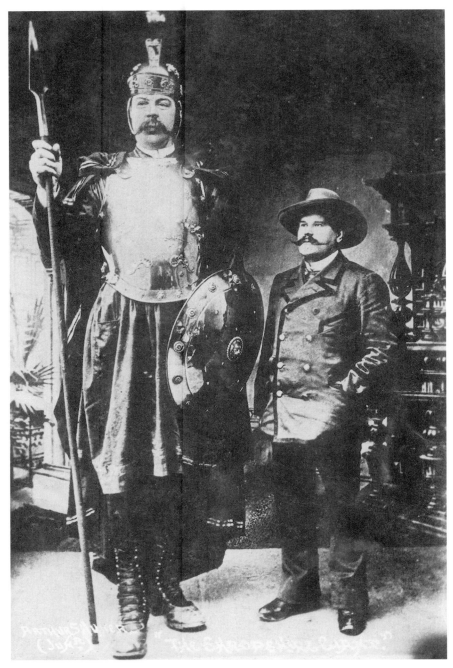

The Shropshire Giant, *c*. 1900. Thomas Dutton was born at Stoke-on-Tern in 1853. In his prime he travelled throughout Europe, dressed in armour and carrying a shield and spear; he was known as the 'British Soldier Giant'. His height was recorded as 7ft 3in, but on the reverse of this postcard that was taken in Belgium it is recorded as 7ft 6in. The height of his attendant is recorded as 5ft 6in. He weighed 23 stone, wore size 18 boots and walked at 8mph. In later years he took part in the local carnival with Tom Sillitoe who was only half his size. He died in 1924.

INTRODUCTION

This book concentrates on an area to the east of a line from Shrewsbury to the border of Cheshire and north of a line from the county town to the Staffordshire border, roughly following the old A5. This area lies on the Shropshire Plain and is made up of rich fertile farmland. In parts the land is undulating but at Hawkstone there is a steep sandstone ridge that rises abruptly to a height of 647ft. It's the highest of a chain of sandstone outcrops that cross the north of the county in a crescent shape. To the west is Whixall Moss. Since the seventeenth century large tracts have been drained and used for farming but there are still areas of wet marshy land with 8ft seams of peat which is cut for horticultural use. The Moss is rich in plant and animal life and was saved in 1981 as a nature reserve. The two main rivers that drain this part of the county are the Roden and the Tern. The Roden rises in Whixall Moss and runs into the Tern before joining the Severn at Atcham. The old Shrewsbury Canal and branches of the Shropshire Union Canal have also left their mark here. It is also the home of heroes such as Sir John Talbot, known as 'the scourge of the French', Robert Clive, later Lord Clive of India, and Sir Rowland Hill, one of Wellington's commanders in the Peninsular War and at Waterloo, all of whom were born locally. The area contains three market towns, Whitchurch, Market Drayton and Newport, many historical and attractive villages and hamlets and lots of straggly settlements and isolated farms.

Whitchurch can trace its history back to Roman times with the building of a fort on Watling Street called Mediolanum, about half way between Wroxeter and Chester. Before the Norman Conquest it was part of the Kingdom of Mercia and was known as Westune, the western settlement. After 1066 the land was given to William de Warenne who became the first Earl of Surrey. In about 1085 he built a church of white Grinshill stone, which gives the town its modern name; first in Latin as Album Monasterium, then into the French Blancminster and finally English as Whitchurch. By the fourteenth century the town prospered and was the home of craftsmen and a thriving market. For many years the town's prosperity brought attacks from over the Welsh border, the worst being in 1404 when most of the town was plundered and burned. The town's recovery was slow but in 1540 the historian John Leland reports, 'the tounne of Whitchurch hath a veri good market,' and in 1550 a Free Grammar School was opened by Sir John Talbot, Rector of Whitchurch. At the outbreak of the Civil War in 1641 the town was loyal to the king. Lord Chapel made his headquarters there but when he took most of his troops north to Warrington the town was taken by Sir William

Brereton and 800 Parliamentarian soldiers. A year later the town was liberated by Prince Rupert and 14,000 men as they marched through on their way to Yorkshire, but the Parliamentarians continued to control the town until the county was finally secured by their troops in 1646. In 1650 the plague spread north from Shrewsbury and killed 113 people, roughly one-fifth of the population of the parish.

The beginning of the eighteenth century saw the collapse of St Alkmund's church, the building that gave the town its name. A shocked community donated over £5,000 and by October 1713 a new church had been consecrated. The new church coincided with the building of some fine Georgian houses and the town prospered with the growing number of shopkeepers and craftsmen settling there. A branch of the Shropshire Union Canal entered the town in 1811 and by September 1858 a rail line ran from Shrewsbury to Crewe. This brought in larger industry and allowed established firms like James Joyce to export their clocks all over the world. During the First World War the town was affected by a large army camp set up at Prees Heath and capable of accommodating around 30,000 troops at a time. During the Second World War the camp was used to detain foreign nationals and later as an airfield to train bomber crews. Between the wars new houses were built to replace dwellings unfit for habitation. This continued after 1945 with estates being built at Queensway and Wrexham Road. During the twentieth century the population of Whitchurch nearly doubled as it is ideally situated for commuters, with excellent road links to Chester, the Midlands and North Wales.

Part of the site now occupied by Market Drayton was known in Saxon times as Draitune, which means a farmstead near where loads are dragged. After the Norman Conquest a castle was built of which nothing now remains and in the Domesday Survey in 1086 the settlement was worth only ten shillings. William Pantulf gave the settlement to the abbot of the Cistercian monastery of Combermere, near Whitchurch. On 8 November 1245 Henry III granted a charter to the abbot, giving him authority to hold a weekly market on Wednesdays and a three-day fair. A new town was created and was controlled by the abbey until the reformation, when Sir Rowland Hill, the first Protestant Lord Mayor of London, became lord of the manor. At the outbreak of the Civil War the town was Parliamentarian. It was attacked several times by Royalist troops without success until March 1644 when Prince Rupert captured the town, killing twenty-two roundheads and capturing forty more. The following year Charles I passed through the town and is reputed to have lodged at the Crown. The inn is one of the buildings to survive the Great Fire of August 1651 in which 140 houses were destroyed. One of those was the market house in the High Street, which was quickly replaced allowing the town to live up to its name and provide a market for a large area. The market flourished there for over 200 years until it moved into temporary accommodation in an old malt house before moving to the Buttercross, erected in 1824. Extra trade was brought in with the opening of a branch of the Shropshire Union Canal in 1835 and the railway in 1863. The first section of rail linked the town to Nantwich and four years later a second section was opened to

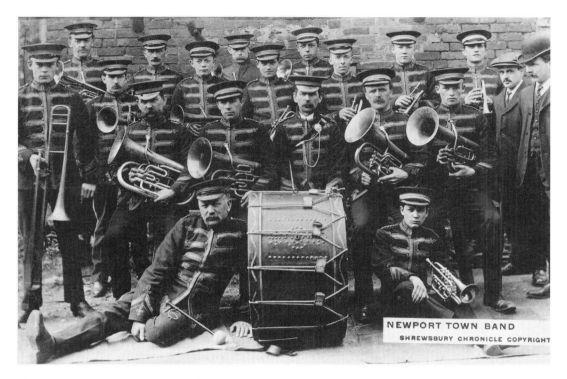

The Newport Band, June 1912. The band was also known as the Newport Black and White Orchestra. Over the years they performed at many functions, including the Newport Carnival. The writer of this card informs Miss B. Adderley of Norfolk that the band have just had their new uniforms.

Wellington. Both modes of transport declined in the twentieth century. The line between Wellington and Nantwich closed in September 1963 but after years of neglect the canal found a new lease of life and is now a major tourist attraction. A new cattle market was opened near the railway station in 1872. It was known as the Smithfield and it moved the sale of animals off the streets of the town. Two other markets were the annual Damson Fair that brought mill owners from Lancashire to buy the crop of locally picked damsons to use for dyeing cotton, and the second was gingerbread, made world famous by the Billington family from a secret recipe. The twentieth century saw the town grow rapidly with many new houses built. Local people found employment in factories opened by Palethorpes or Müller and the population grew from around 3,000 at the beginning of the twentieth century to about 10,000 at the end.

The area now occupied by the town of Newport was until the twelfth century a small fishing settlement in the Manor of Edgmond. The district was very marshy and contained several well-stocked fishponds, most of which have been drained and used for other purposes. Robert de Belesme, the Earl of Shrewsbury rebelled against Henry I in 1102. The rebellion was defeated and a grateful king, who had been supported with men and money by the fisher folk, granted the settlement a charter, allowing it to develop into a new town known as Nova Burgo or New

Borough. One obligation the new borough had to pay was to supply the Royal Court with fish, wherever it might be. This continued until 1275 when the burgesses paid £5 to release them from the obligation unless the king was in Shropshire. The town belonged to the Crown until it was granted to Lord Audley in 1227. It was first called Newport in 1221. King Edward II visited in 1322 and was pleased with the accommodation provided for him by the extravert landlord Robert Levere at the Antelope Inn. In 1485 Henry Tudor, later Henry VII, marched his army through the town on his way to do battle with Richard III at Market Bosworth. Charles I passed through the town twice during the Civil War. On his second visit in 1645 he stayed with a Mr Piggott of Chetwynd, while two princes, Rupert and Maurice, lodged at the Swan in Newport. There was also some fighting around the town after the Battle of Worcester in 1651 when Charles II fled towards Boscobel. Two fires devastated the town; the first broke out in a blacksmiths shop on 19 May 1665 destroying much of the medieval town. The second occurred on 8 October 1791 in an area known as the Tan Yard. It destroyed the tannery, eighteen houses and several barns and stables.

William Adams was born in the town in 1584. He went to London, became a member of the Company of Haberdashers, made a large fortune and was a great benefactor to Newport. In 1656 he founded a Free Grammar School, which cost £7,500 and also included a library, houses for the master and usher and a pair of almshouses for two men and two women. He also bequeathed £550 towards a market hall that was erected in 1663. The old market was replaced in 1860 at a cost of £13,000. It gave accommodation for the Friday market and had a large assembly hall for social events. In the twentieth century the hall also housed an egg-packing plant and a cinema. Like Whitchurch and Market Drayton the town has grown and adapted in the last hundred years. In 1901 the population was just over 3,000 but by the end of the century it had grown to around 10,000.

The views in this book are taken from the vast collection of Shropshire postcards collected by Ray Farlow.

1

WHITCHURCH

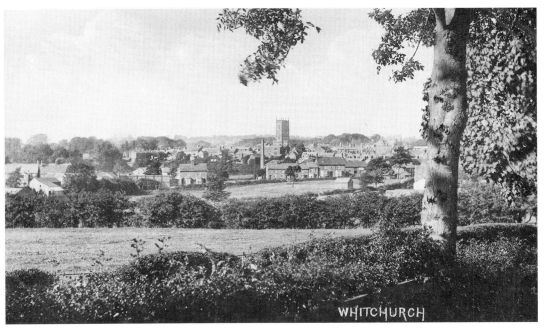

Whitchurch, *c.* 1900. This photograph, taken from the south-west, was one of many superb views taken of the town by Josiah Rowland Crosse who had a photographic studio and a fancy repository at 44 Watergate Street. In the centre is the tower of St Alkmund's Church and just to the left of the tower is the chimney of the corn mill. The mill stood on the bank of the canal near the Wharf and was marked as 'disused' on the 1901 Ordnance Survey Map. In Roman times the name of the settlement was Mediolanum. It was known as Westune by the Saxons; but its name was changed after the Normans built their new church there out of white Grinshill stone, first by the Latin Album Monasterium, then by the French name Blancminster, before being anglicised to White or Whitchurch.

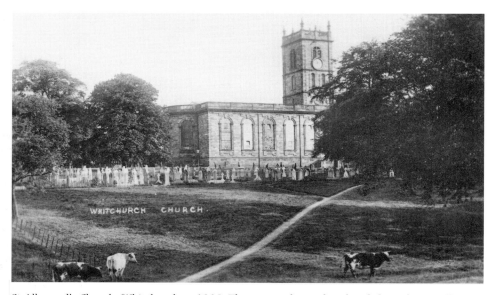

St Alkmund's Church, Whitchurch, *c.* 1910. There are only six churches dedicated to St Alkmund and they all lie in the ancient Saxon kingdom of Mercia. They are named after Prince Alkmund, the son of King Alhred of Northumbria. Alkmund was murdered in about 800 and was buried in Derby where the first church was dedicated to him. The other four churches are in Shrewsbury, Aymestry, Blyborough and Duffield. This church was built in the Classical style and was erected between 1712 and 1713 at a cost of about £5,000. It replaced the previous church after the tower collapsed on the evening of Sunday 31 July 1711 and destroyed most of the building.

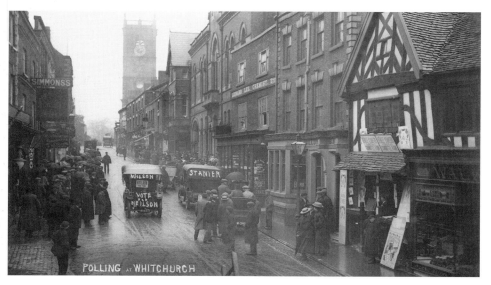

High Street, Whitchurch, 1908. Two rival candidates, Francis Neilson for the Liberals and Beville Stanier for the Conservatives, campaign for votes in the May 1908 general election. The election was won by Stanier with a majority of 951 votes. He successfully defended the seat two years later against a different opponent. He lived for a number of years at Peplow Hall before moving to The Citadel at Weston-under-Redcastle where he died in 1921 at the age of fifty-four. The timber-framed building on the right is Mr Stanier's Central Committee Room. The writing on the cars was scratched on to the negative by the photographer.

High Street, Whitchurch, *c.* 1934. Ye Olde Shoppe and Walker's bakery next door were erected between the late fifteenth and early sixteenth century. During the seventeenth and early eighteenth centuries the building was used as an inn known as the Swan. For most of the nineteenth century it was known as the Cooperage where barrels, dolly tubs, cheese moulds and other articles were made. In 1879 Thomas Ankers opened a bakery in the right-hand section of the house. The business was taken over by John Walker in 1885 and they traded under that name for several generations and several new owners. Arthur Wood opened an antique shop in the left-hand section in about 1934. The shop was later converted into a greengrocer's before being absorbed into the bakery.

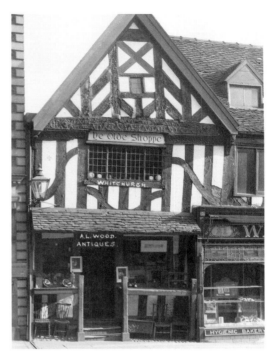

High Street, Whitchurch, *c.* 1916. This fine view is of the south-west side of the High Street during the First World War. The first shop on the left is the Maypole, one of a chain of shops around the country, with a fine array of goods in the window. The man standing in the doorway is a shop assistant at Edward Jones's, another grocery shop and just above is the barber's pole belonging to Walter Speed, a hairdresser and tobacconist. The next shop with the suits hanging outside belonged to Bradley's cloth shop. The next building housed a refreshment room belonging to Joseph Fulgani who also ran a fried fish shop in Watergate. The large signs above belong to the Alexandra Temperance Hotel, which was managed by Frank Whiston.

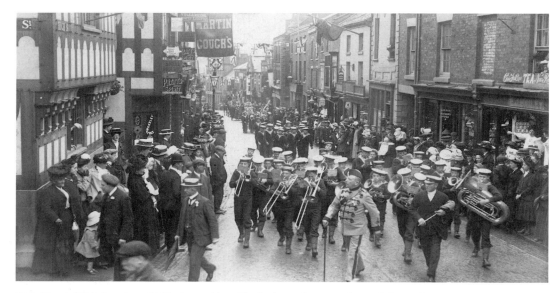

High Street, Whitchurch, *c.* 1912. A naval band leads the cycle carnival out of the High Street into Church Street. The timber-framed building on the corner is the Black Bear Inn. In 1896 it belonged to the brewery of Sykes & Co. of Liverpool but by 1901 it was under the control of the Shrewsbury and Wem Brewery. The landlord was George Windsor who was reported to have kept the house clean and in good repair. The inn consisted of a bar and four rooms downstairs with six rooms on the first floor. There was accommodation for ten lodgers and stabling for thirty-two horses at night and fifty by day. Just below is the sign for Martin Gough's circulating library and stationery shop while on the right is the grocery shop belonging to Ernest Bailey where you could purchase 'First Class Tea' for just 6*d* a pound.

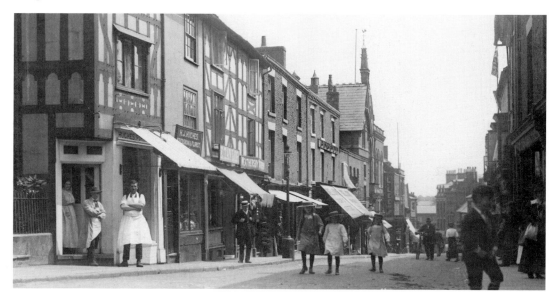

High Street, Whitchurch, *c.* 1915. This view shows the fine array of shops on the north-east side of the High Street, looking towards the Town Hall and market. The three people on the left are standing outside the pork butcher's shop belonging to a Mr Hughes, perhaps the man with the bow tie in the centre. Below is the flower and seed shop belonging to Henry James Hughes who also had a nursery in Station Road. Next door was another butcher, Ernest Taylor, while beyond him is the stationery shop belonging to Eliza Weathersby. The large awning with the writing is advertising Howell Brothers' drapery shop while just beyond the Town Hall is a sign for Leonard Lee's chemist and grocery shop.

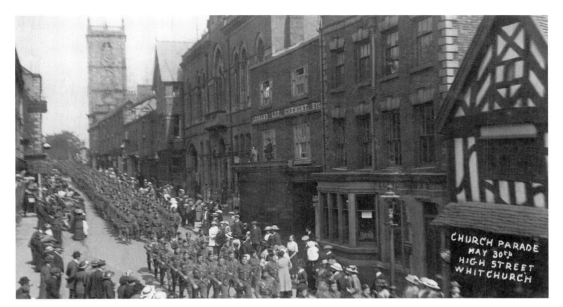

High Street, Whitchurch, 30 May 1915. Large crowds line the High Street to watch the men of the 15th, 16th and 17th Battalions of the Highland Light Infantry and the 11th Borderers Regiment march through the town after a church parade. They are marching back to camp at Prees Heath, which lies 2 miles south of Whitchurch, and was the home of thousands of troops during the First World War. The large building to the left of Lee's shop is the Town Hall, which was opened in October 1872. It was designed in the Domestic Gothic style by Thomas Lockwood of Chester. It was badly damaged by fire in 1941 and was replaced by the Civic Centre in the early 1970s. The building to the right of the chemist shop is Lloyd's Bank.

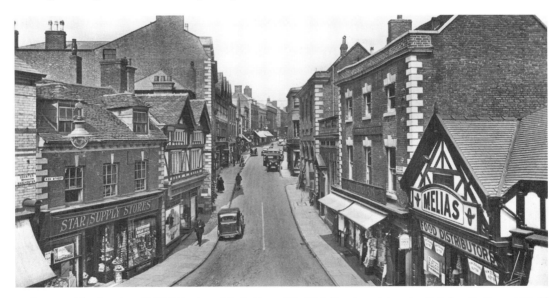

High Street, Whitchurch, c. 1938. This view of the bottom of the High Street was taken shortly before the Second World War. Note the sign on the building on the left directing travellers up the High Street to Chester and Manchester. Star Supply Stores on the left and Melias on the right were both grocery shops. Just above Melias is Liverpool House which was built in about 1775. From 1901 until the 1970s it housed a drapery shop run by the Dudleston family. Further up are two banks, the Midland Bank, housed in a building erected in 1926, and Barclays Bank, situated in the old market hall that was erected in 1715.

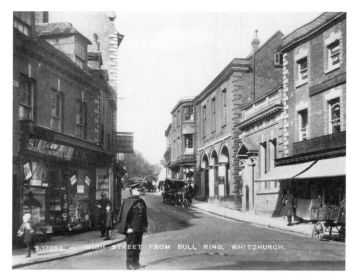

High Street, Whitchurch, *c.* 1925. A county policeman stands on point duty at the junction of High Street and the Bull Ring. The three rounded arches of the old market hall are to the right of the car. The ground floor was used as an open market while the upper floor was used as a town hall. By about 1877 the building was converted into a bank and the arches to the open ground floor were filled in. The bank later merged with Barclays. The purpose-built Midland Bank to the right occupies the site of Bradley's butcher's shop which was demolished in 1926. The sign of the White Bear Inn can be seen above the policeman's head. It was first licensed in the late eighteenth century. In 1896 it belonged to William Yates & Co., which had a brewery in Manchester.

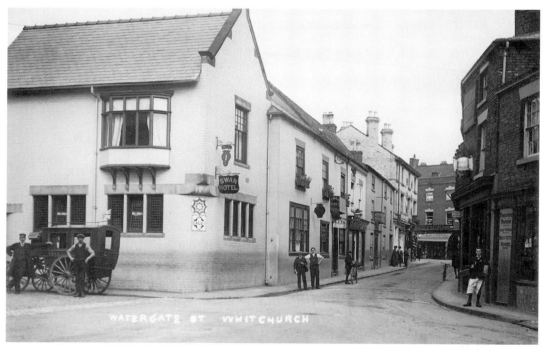

Watergate Street, Whitchurch, *c.* 1905. Most of the left-hand side of the street is occupied by two hotels, the Swan and the Star. In 1896 the Swan belonged to Elizabeth Parker of Liverpool but it was occupied by William Manley. It consisted of a bar and four rooms on the ground floor and ten rooms upstairs that provided beds for fourteen guests. The stable was able to accommodate fourteen horses overnight and fifty during the day. By 1901 Mr Manley was the owner of the hotel and extended it by adding a billiard room downstairs and three extra bedrooms on the first floor. Note the coach belonging to the hotel, which would convey visitors between the Swan and the railway station. The Star Hotel belonged to Wright's Crown Brewery of Market Drayton. The landlord was Joseph Palmer who kept it clean and in good repair. In 1896, though, he was taken to court and found guilty of selling adulterated whisky and fined 5*s* plus £1 6*s* 0*d* costs.

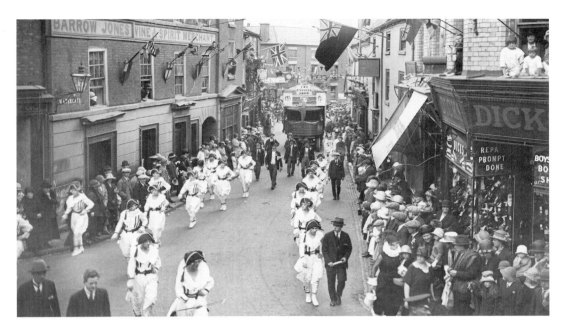

Watergate Street, Whitchurch, *c.* 1925. A troop of men and a Sentinel steam wagon belonging to Leslie Reeves, a haulage contractor, lead the carnival towards the High Street. On the left, almost opposite the Star Hotel, is Barrow Jones, a wine and spirit dealer who occupied those premises from about 1880 until the 1930s. Just beyond and flying the large Union flag is the shop occupied by Ernest Speed, a tobacconist and hairdresser. Behind the steam wagon is another public house, the Lord Hill, which belonged to the Shrewsbury and Wem Brewery. On the right is Dick's boot and shoe warehouse that was run by G. & W. Morton.

Bargate, Whitchurch, *c.* 1905. A delivery cart belonging to a Mr Williams poses for the photographer. There were two firms of that name in the town who would have needed such a vehicle. One was Isaac Williams, a seed and nurseryman, the other was Richard Williams, a pastry cook and confectioner; both were from Green End. The lofty tower of St Alkmund's Church dominates the centre of the view. Just behind the trees on the left is the old Grammar School for boys. It was founded by a former Rector of Whitchurch, Sir John Talbot in 1550. The present building was erected in the Elizabethan style in 1848 and was occupied by the school until 1938. The buildings next to the church are Higginson's Almshouses that were built to accommodate 'six decayed housekeepers'.

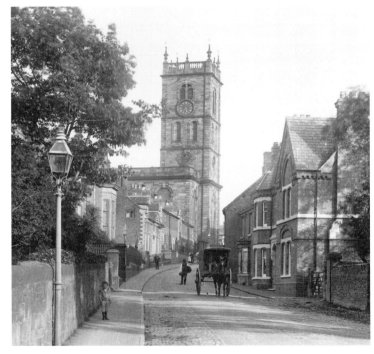

Dodington, Whitchurch, *c.* 1905. Dodington was once a separate hamlet to the south of the town but by the end of the eighteenth century it had become a wealthy suburb with many fine houses. The tower in the centre belongs to St Catherine's Church. It was erected for the Dowager Countess of Bridgewater as a chapel-of-ease in 1836. The architect was Edward Haycock of Shrewsbury who chose a Classical design. The tower is octagonal and the roof is supported by Tuscan columns. The church was made redundant in 1975. The road on the left is Rosemary Lane.

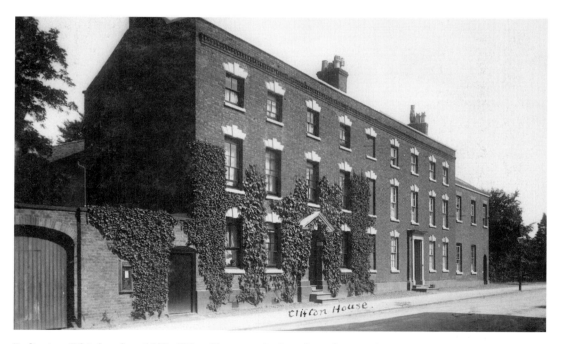

Dodington, Whitchurch, *c.* 1909. Clifton House was built in the early part of the nineteenth century and stands on the opposite side of the road to St Catherine's Church. In 1905 it was occupied by John Harrison German JP, but by 1909 a man called La Penstière was staying there. On the back of the card he wrote, 'I came here in June! I am living in my own house. Do you see "Ching" in one of the dining-room windows? I am going to Clifton on Monday for Ida Pritchard's wedding.' Ching is the Pekinese in the bottom window on the left.

Dodington, Whitchurch, *c.* 1905. The railings on the left lead to St Catherine's Church. Opposite are Elizabeth Langford's almshouses in the Tudor style, built in 1829. They housed four poor widows who each received 5*s* a week. To the left is the seventeenth-century Ellesmere House, a timber-framed building with brick gable ends. In 1992 the plaster hiding the frame was removed and the timber restored. The timber-framed building on the left is the old Manor House, which was built as one dwelling, but split into two cottages sometime after 1860. Parts of the building date back to the mid-sixteenth century and a fine eighteenth-century staircase has been retained in the far cottage.

Dodington, Whitchurch, *c.* 1920. Between 1891 and 1900 Haslam, Barron & Storey were advertised as coach builders in Dodington. They informed clients that they made all types of carriages, that repairs were promptly executed and that competitive estimates were given. By 1905 Barron and Storey had departed while Mr Haslam had opened a coach building business in Bark Hill. Joseph Hopley had taken over the Dodington works and by 1917 the firm was advertised as 'Joseph Hopley & Son, coach and carriage builders, automobile engineers & agents'. During the 1920s the firm concentrated more on engineering and opened another branch on Bark Hill. The building next door with the fine portico is the Congregational Church, built in the Classical Greek style in 1846.

Dodington, Whitchurch, *c.* 1905. Fountain House stands at the junction of Edgeley Road on the left and Sedgeford. The house is close to Watling Street, the old Roman road running through Uriconium (Wroxeter) from London to Chester. The fountain marks the find of a first-century urn in November 1899. It was a burial urn, about ten inches tall, containing burnt bones and ashes. Several other similar finds have been discovered in the area. The fountain was erected by E.P. Thompson in May 1900 and contains a bronze plaque celebrating the find. Note the ladies and the young girls with their fine perambulators.

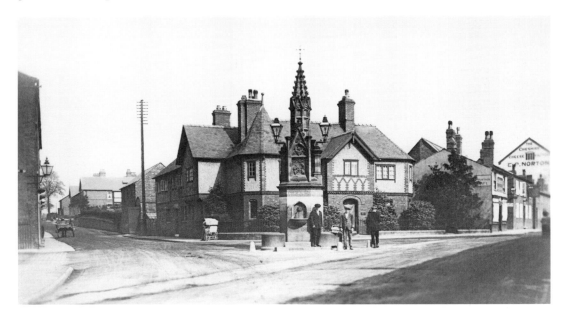

Green End, Whitchurch, *c.* 1930. This is the junction of Station Road (right) and Talbot Street (left). At one time Talbot Street was known as Paradise Street while Station Road was called Tin Hole Lane. The fountain was presented to the town by John Churton in April 1883. It was built out of Scottish granite and Cheshire sandstone and stands as a memorial to 'the great cause of temperance'. The gas lamps were placed there as 'a benefit to the inhabitants and a comfort to travellers.' The house behind was erected as a home and office for Mr Churton who was a solicitor and clerk for the Urban District Council and the Joint Cemetery Board. The sign of the Railway Inn can be seen outside the cottage on the right. The licence and the name were later transferred to Mr Churton's house.

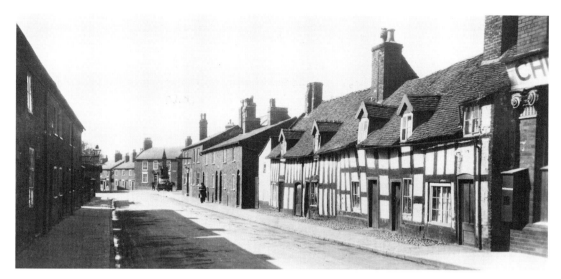

Station Road, Whitchurch, *c.* 1930. This view is looking back towards the fountain at the junction of Green End and Talbot Street. The entrance to Bridgewater Street can be seen just below the gas lamp on the left. The local police station was situated on the corner of Station Road and Bridgewater Street and was under the control of Superintendent George Edge in the 1920s. The timber-framed cottages on the right with their cobbled fronts were built in the seventeenth century. They had two rooms on each floor, had no inside sanitation and were demolished in the 1950s. The building to the right belonged to Glendale Dairy Co. Ltd, who were cheese factors.

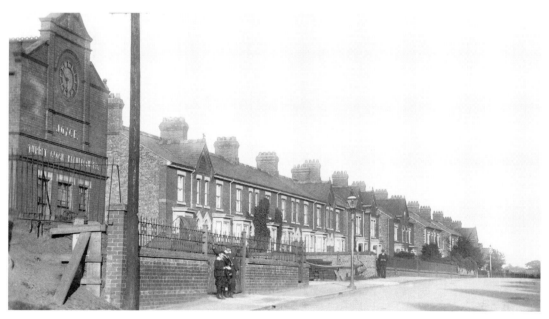

Station Road, Whitchurch, *c.* 1905. On the left is the new factory building belonging to Joyce Clocks that was built in 1904. James Joyce moved to Whitchurch from Ellesmere in 1790. He was the son of a clockmaker and he set up business in the old Crown Inn on the High Street. As the firm grew and exported clocks all over the world they expanded into this purpose-built factory. Note the writing on the wall 'Joyce Turret Clock Manufacturer'. They were responsible for supplying many of the double-sided clocks seen on railway stations, which bore the logo 'Joyce of Whitchurch'. In 1964 the factory was gutted by fire, but despite the damage, production of their world-famous clocks was not affected. The firm was taken over by John Smith & Sons of Derby in 1965.

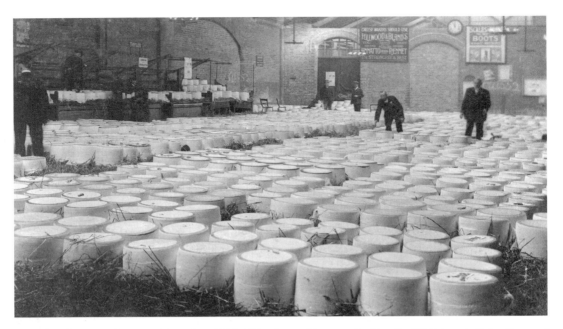

Whitchurch Dairy Show, 10 November 1908. This cheese fair, organised by the Whitchurch Dairy Farmers' Association was advertised as the last and biggest of the season. It was the twentieth show to be held by the association and £300 of prize money attracted keen competition. One of the judges, Professor Drummond, declared, 'cheese shown was on the whole of admirable quality.' The Blue Ribbon of the show was won by Mrs Nunnerley of Bradeley Green who received a gold medal and challenge bowl.

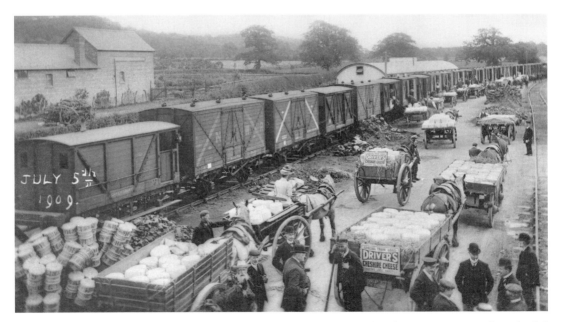

Whitchurch, 5 July 1909. Wagons line the track in the goods yard at Whitchurch station waiting to be unloaded for the cheese fair. They came from far and wide as the poster on the back of the cart reveals. 'Special Train Load – Driver's Cheshire Cheese – Bradford, Leeds, Wakefield'. 101 tons of cheese was on show compared to 79 tons the previous year and prices ranged from 62s a ton for best quality down to 49s a ton for lower grade cheese.

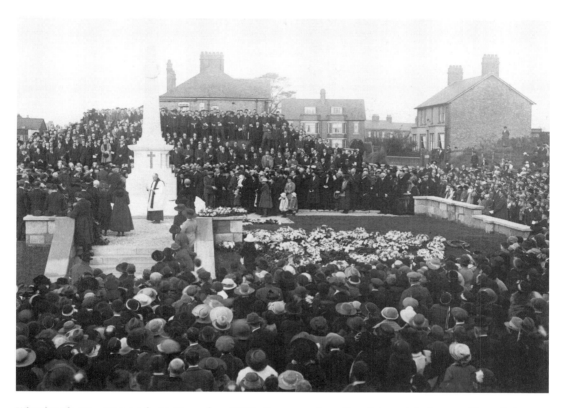

Whitchurch War Memorial, 11 November 1920. Huge crowds gathered to watch the unveiling of the war memorial on Armistice Day in 1920. The memorial was erected on the corner of Station Road and Queens Road on land given by the Misses Kent who lived at 58 Green End. The memorial is inscribed with the names of 156 Whitchurch men who died in the First World War and the twenty who died during the Second World War. The building immediately behind the memorial was once owned by John Huxley & Co., who were coach builders and motor engineers.

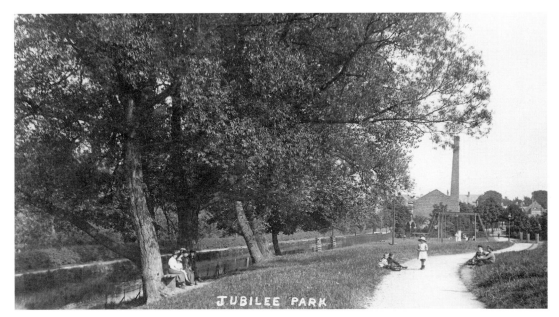

Jubilee Park, Whitchurch, *c.* 1910. To celebrate Queen Victoria's Golden Jubilee in 1887 it was decided to provide the citizens of Whitchurch with a park. Around 11 acres of land bordering the canal was purchased for about £1,250 and paid for by public subscription. Ten years later landscaping and extra facilities were added to celebrate Victoria's Diamond Jubilee. These included an avenue of sixty lime trees from Mill Street to the park and a bandstand donated by Mrs Nottingham, the widow of Dr John Nottingham who lived at the Mount. The canal on the left leads up to the Wharf, and the building with the chimney is the corn mill that was marked as disused on the 1901 Ordnance Survey map.

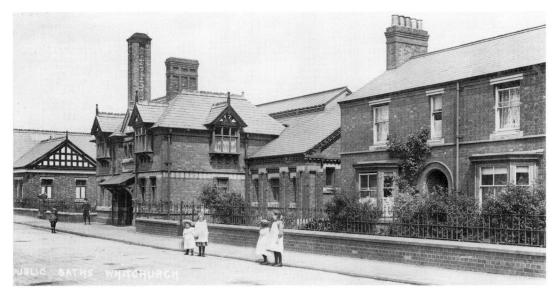

Brownlow Street, Whitchurch, *c.* 1905. The building on the left is the public baths, built from brick in the Queen Anne style between 1890 and 1891. They cost £1,500 and were a gift to the town, again from Mrs Nottingham. There was a pool measuring 48ft by 24ft and several slipper baths, where the poorer people of the town could enjoy the luxury of a hot bath. The baths were under the control of the Urban District Council who would not allow mixed bathing for many years. In 1905 the Baths Superintendent was Robert Marshall who lived in a house provided next door.

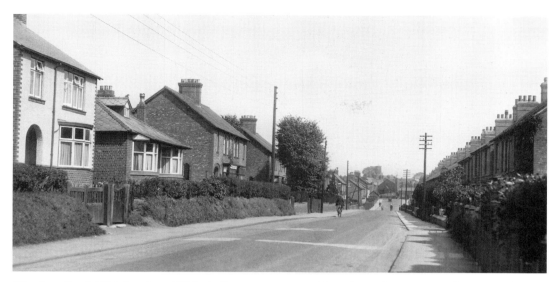

Wrexham Road, Whitchurch, *c.* 1935. As the name suggests this is the road west to Wrexham in Wales. The photographer is looking back towards town. On the horizon is the tower of St Catherine's Church in Dodington and just below on Highgate is the Unitarian Church of Our Saviour. The church is not listed in *Kelly's Directory* of 1926 but in 1917 they were offering services on Sundays at 11.00 a.m. and 6.30 p.m. Most of the houses in this view were erected in the first half of the twentieth century. Since 1945 a new housing estate has been built in the area.

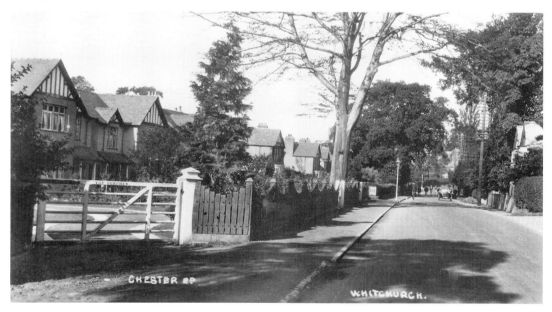

Chester Road, Whitchurch, *c.* 1925. As in the previous photograph, the name of the road tells us the direction it is going in, in this case to Chester. The road is lined with some very elegant houses, built in the early part of the twentieth century. The Beeches on the left was occupied by George Edge. In 1917 he was living at Oakleigh in Chester Road and was in business as a builder with a yard at Castle Hill. By 1922 he had moved to the Beeches and was trading as George Edge & Son Builders. Four years later he had gone into business with Arthur Davies and traded under the name George Edge & Son & A. Davies Builders until the mid-1930s by which time they were also wireless dealers with a shop in Watergate Street. By 1941 the building business had gone but there was a business in Mill Street called E. & D. Radio Service.

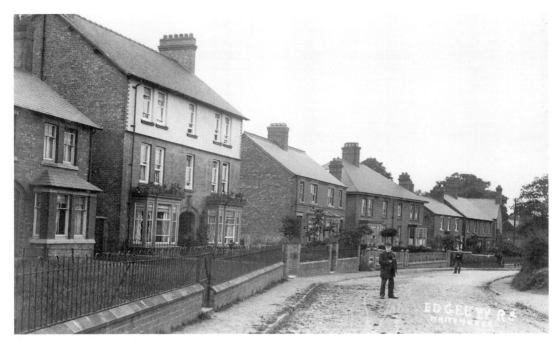

Edgeley Road, Whitchurch, c. 1900. The road leads to the little hamlet of Edgeley that lies 1½ miles south-east of Whitchurch. On the Ordnance Survey map of 1899 only these nine houses are marked and only two names are listed as living in the road in 1905. They were William France and the Revd George Lee, the Primitive Methodist minister who lived at the Manse. In the early part of the twentieth century a number of fine houses were built on the opposite side of the road and by 1913 sixteen residents are listed there. Another house was built in the space to the right of the three-storey building in 1906.

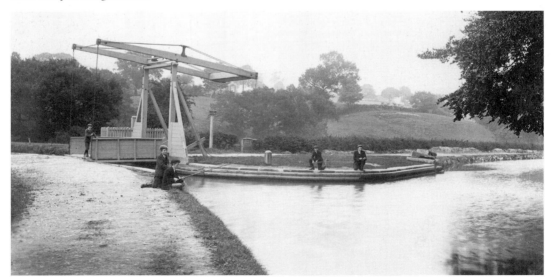

New Mill Bridge, Whitchurch, c. 1900. The Shropshire Union Canal was constructed between Chester and Netherpool on the banks of the River Mersey and opened in 1795. Ten years later Ellesmere was connected to Chester and shortly after, Netherpool was renamed Ellesmere Port. As the canal bypassed Whitchurch, a branch from The Chemistry as far as Sherryman's Bridge was opened by 1808 and was extended to Mill Street by 1811. The bridge is counterbalanced by weights so that it can be raised and lowered with ease and was constructed out of wood.

2

AROUND WHITCHURCH

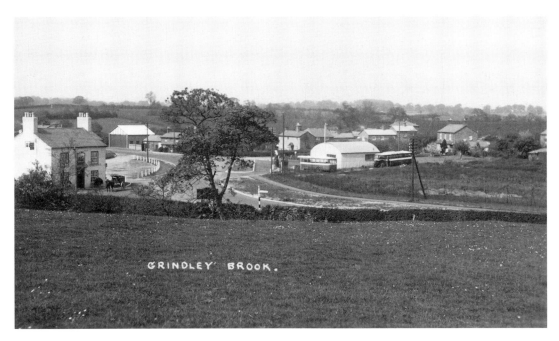

GRINDLEY BROOK.

Grindley Brook, *c*. 1930. The village lies 1½ miles north-west of Whitchurch, right on the border of Wales. The building on the left is the Horse and Jockey Inn and the landlady in 1930 was Mrs Ann Pocketts, whose family had been running the inn from about 1900. Her son William was a haulage contractor in the village and was also the secretary of Grindley Brook Recreation Room. In 1926 another inn, the Canal Tavern, was occupied by Alfred James Hine. By 1929 the Canal Tavern was not listed in the village but Mr Hine was listed as proprietor of the Grindley Brook Hotel.

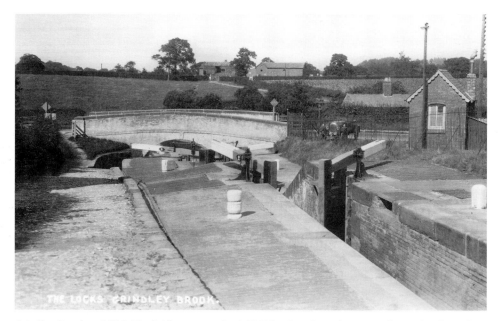

Grindley Brook, *c.* 1920. The bridge carries the A41 Whitchurch to Chester road over the Shropshire Union Canal as it makes its way into Cheshire. Three locks are needed here to take the boats down to the lower level. Some industry developed on the canal side, which included a boatyard, lime kilns and a steam corn mill. The building on the right is the gatehouse to the mill.

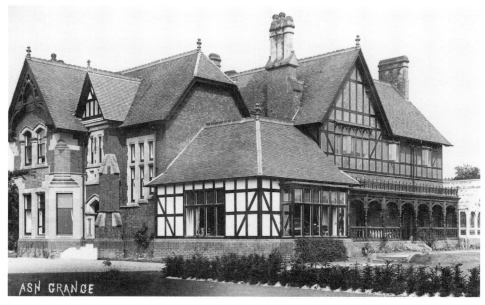

Ash Grange, *c.* 1905. The village of Ash lies 2 miles south-east of Whitchurch on the road leading to Market Drayton. The hamlets of Ash Magna, Ash Parva and Old and New Woodhouses were formed into a new ecclesiastical parish on 15 October 1844 from the parish of Whitchurch. Ash Grange is a substantial late Victorian mansion, inhabited in 1895 by Nathanial Davies. In 1900 Charles Taylor was living there and from about 1905 until the 1930s Lord Gerald Richard Grosvenor was in residence. The mansion is reputed to be occupied by a ghostly monk.

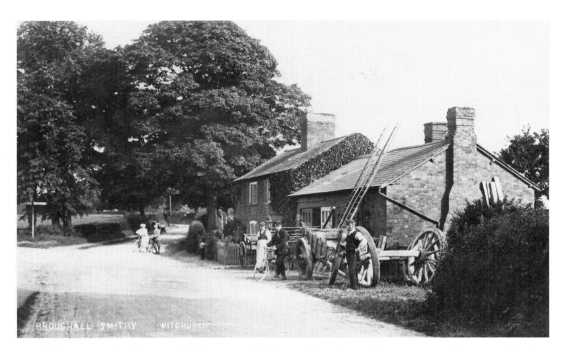

Broughall, *c.* 1905. The photographer has persuaded the men from the smithy, a postman and two genteel cyclists to pose for this rare view of the hamlet. It lies a mile north-east of Whitchurch on the road to Nantwich. The main landowners were Earl Brownlow and Mrs Nottingham. Between 1890 and 1905 all the commercial residents are listed in *Kelly's Directory* as farmers, except for Thomas Walker who was the blacksmith at Cross Barns.

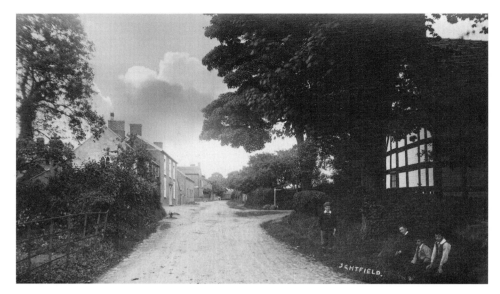

Ightfield, *c.* 1905. The photographer has his back to Whitchurch. The turning on the right is to Market Drayton, while the road straight ahead leads to Burleydam. The second house on the left is the post office. In 1905 Mrs Hannah Rogers was sub-postmistress and mail was received via the Whitchurch sorting office. Postal orders were issued and paid there, but for money orders and telegrams, villagers would have to travel to Calverhall a mile away. The boys are standing outside a timber-framed farm house. A war memorial commemorating villagers who died in the First World War was placed on the corner where the sign post is situated.

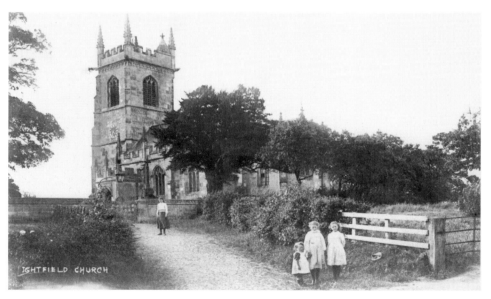

Ightfield, *c.* 1906. Four young girls pose for the photographer J.R. Crosse outside the church of St John the Baptist. The church is Perpendicular in style and was heavily restored, with the chancel being rebuilt, in 1865 at a cost of around £3,000. During a violent storm in 1908 one of the pinnacles from the tower was toppled and smashed through the nave roof, causing a great deal of damage. This card, sent by G.W.S. of Ightfield to Miss Grace Feasey of Camberwell, London, informs her, 'The above is my address, everyone knows me, including the police.'

Calverhall, *c. 1935*. The large building on the right is the village hall that was a gift of the Heywood family in 1875. In front is a large bowling green, while the building on the left is the village post office and shop. In 1935 the sub-postmistress was Mrs Edith France with letters arriving daily via the Whitchurch sorting office. The shelter on the left was erected in memory of John Pemberton Heywood in 1885. This card was sent by Monty of Cloverley Hall to Mrs Pidgion of Canterbury who enquires 'Are you getting a calendar for Australia?'

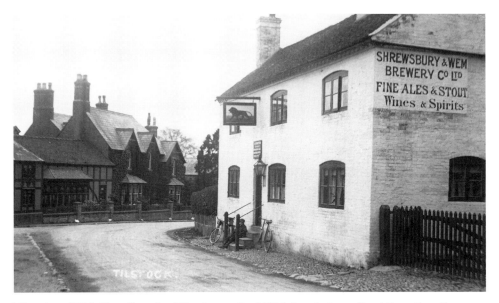

Tilstock, *c. 1910*. The village lies 2½ miles south of Whitchurch. In medieval times the village was known as Tildestok, derived from the old English meaning 'the farm belonging to Tidhild'. The inn is the Red Lion, which was first licensed in the early nineteenth century. In 1896 the inn belonged to Henry Kynaston of Wem Brewery but was run by Elizabeth Maddocks. There were three rooms downstairs and five rooms upstairs, able to accommodate six guests. The inn and stables were reported as being 'in good repair and clean,' but in a similar report in 1901 it was stated that, 'the house requires painting and whitewashing and the stables repairing.' On the reverse Jack informs his mother and father. 'This is where I had my first pint of beer in my life.'

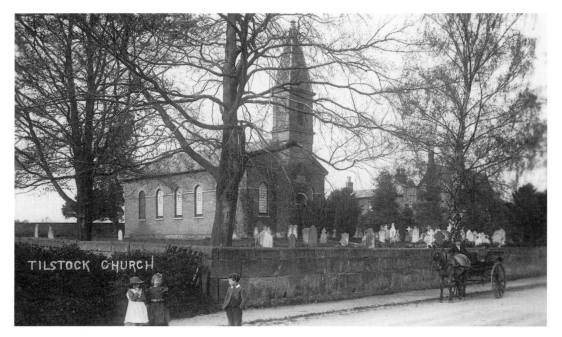

Tilstock, *c.* 1910. Christ Church was designed by Edward Haycock senior of Shrewsbury and was erected in 1835. It was built out of brick and has a narrow tower containing a clock and bell, which is topped by an elegant pyramid roof. The round-headed windows have cast-iron glazing bars. The living was worth £270 a year, which included a vicarage. The living was in the gift of the Rector of Whitchurch and was occupied in 1910 by the Revd Edward Wynn Huntingford.

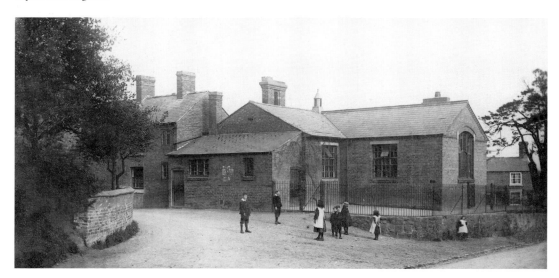

Tilstock, *c.* 1910. The school was built in 1834 and enlarged in 1892 to accommodate 130 children. The school was described in *Samuel Bagshaw's Directory* of 1851 as 'a modern erection of brick, with a residence for the teacher, which stands on the site of the old church, and was built by subscription and a grant of £60 from the National Society. Among the most liberal donors towards its erection were the Countess of Bridgewater, who gave £60, the Revd Charles M. Long, rector of Whitchurch, £60, and Lord Farnborough £20. About 100 children attend the school, which is chiefly supported by the incumbent of the church and a few benevolent individuals. The minister and his lady assiduously superintend the school.'

3

MARKET DRAYTON

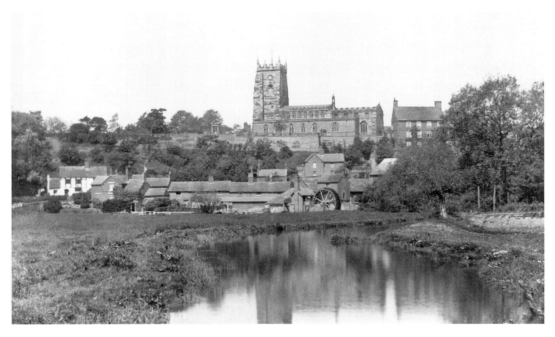

Market Drayton, *c.* 1905. This view was taken from the Newport road and shows the church of St Mary high above the River Tern. Parts of the church date back to the Norman period but it was altered by the Georgians and completely restored by the Victorians who reopened the church in January 1882 after spending between £8,000 and £9,000 on the project. Robert Clive, who was born nearby and is better known as Clive of India, is reported as a boy to have climbed the outside of the tower – a feat that would have taken great courage. The water mill in the centre is one of seven that used the waters of the Tern as a power source.

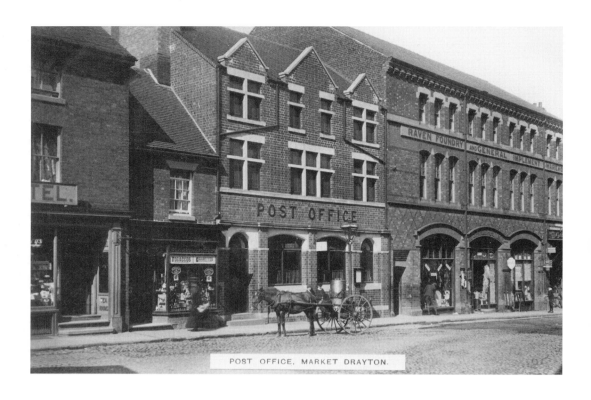

POST OFFICE, MARKET DRAYTON.

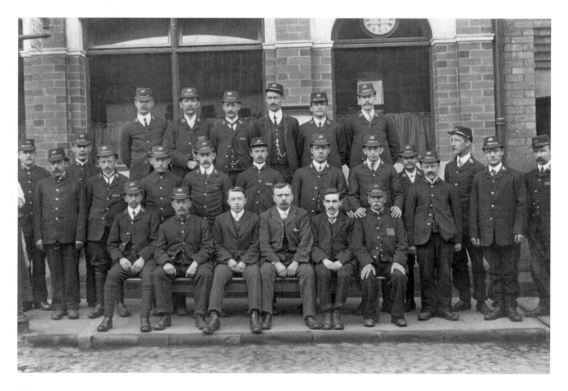

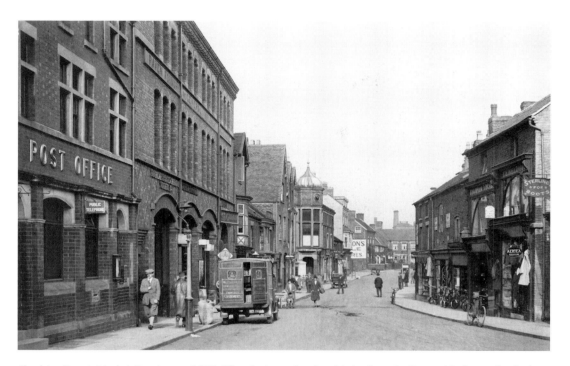

Cheshire Street, Market Drayton, *c.* 1935. The photographer has his back to the Butter Market and is looking towards the junction with Queen Street. The new post office is on the left next to the grocery shop belonging to the Silverdale Co-operative Society. The garage to the right belonged to Thomas Hockenhull who started there just after the First World War. The building with the fine dome is the Town Hall which was built in 1897. As well as offices it could seat 600 people and once housed the fire station, library, market hall and cinema. On the right is the sign for Sterling's boot and shoe shop, Thomas Billington's clothes shop, the Salopian Arcade and the cycle repair shop belonging to Beresford & Co. who also had a tobacconist shop two doors further down.

Opposite: Cheshire Street, Market Drayton, *c.* 1911. The post office opened in 1911 and it was described in 1913 as a 'Post Office, Money Order & Telegraph Office & Telephonic Express Delivery Office'. The postmaster was Thomas Comben, perhaps the man in the centre of the front row, who was in charge of a large workforce. Letters arrived and were sorted from all over the country. The first town delivery commenced at 7 a.m., and there was a second delivery at 2.30 p.m. except on a Sunday and a third delivery at 7.15 p.m. except on Sundays and Thursdays, which were early closing days. The large building to the right is the Raven Foundry and General Implement Warehouse. It was founded as the Eagle Foundry in 1877 and was owned by John Rodenhurst. He manufactured a variety of domestic and agricultural implements. He also opened the garage on the right that was later taken over by Thomas Hockenhull. The post office, foundry and garage were demolished in 1974.

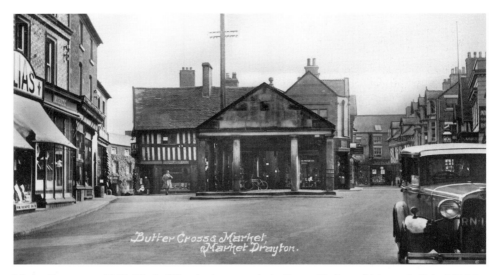

Market Drayton, *c.* 1930. The building in the centre is the Butter Market, which was built in 1824 for the sale of butter, cheese, eggs and poultry. In the 1950s it was described as ugly and an eyesore with many locals wanting it demolished, but luckily for the town the council voted to retain it after a very close debate. At the beginning of the eighteenth century the timber-framed building was an inn called the Cheshire Cheese. The Billington family, famed for making gingerbread, acquired the building in about 1878 and there developed the popular pastime of dunking pieces of gingerbread into port. The delivery bike under the market belongs to Hepworth the tailor whose shop can be seen between the right-hand columns. On the left are the shops of Melias the grocer and William Shutt the pork butcher.

Stafford Street, Market Drayton, *c.* 1910. This view is looking back towards the High Street. The white-fronted building is the Crown Inn that sits at the corner of the two streets. It is an ancient inn that survived a great fire in the town in 1651 and according to local folklore it was visited by Charles I in 1645. The house to the right is another inn called the Unicorn, which in 1901 was owned and occupied by Joseph Martin. It had a bar and four rooms downstairs and six rooms on the first floor. At the rear was stabling for thirty horses at night and sixty during the day. Next is the shop of Hayman Slann, a smallware dealer, and the jewellery shop belonging to George Lashmore. The sign over his shop reads 'The Noted Shop for Watch Repairs'.

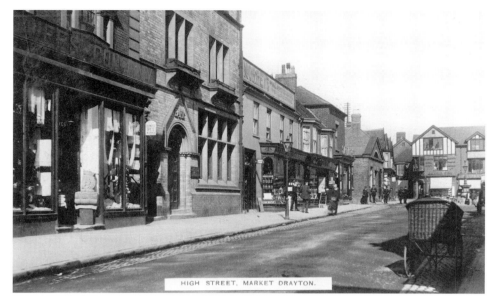

High Street, Market Drayton, *c.* 1925. The bank on the left belonged to the Birmingham District and Counties Bank in 1891, but had changed their name to the United Counties Bank Ltd by the outbreak of the First World War and were absorbed by Barclays Bank by 1917. The shop behind the lamp-post belonged to George Morrey, a pharmaceutical chemist who began trading there in about 1900. The people at the bottom are standing on the corner of the Shambles, a narrow street leading through to Shropshire Street. The building behind them, built in1860, is the Meat Market that held a general market on a Wednesday and a meat market on a Saturday. It was demolished in 1960.

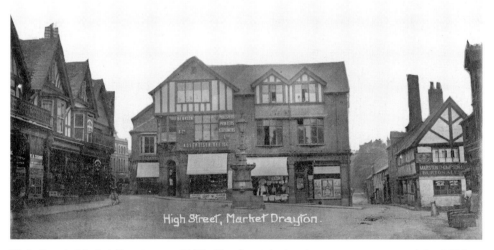

High Street, Market Drayton, *c.* 1910. The fountain in the centre was erected in 1898 to commemorate Queen Victoria's Diamond Jubilee the previous year. It only had a short life and was taken down in the 1930s to make way for road widening. In 1905 Bennion & Co., just to the left of the fountain, were advertised as 'wholesale and retail printers, publishers, book sellers, book binders, stationers, newsagents, music sellers & fancy repository, & proprietors of the "Newport & Market Drayton Advertiser," "The Stone & Eccleshall Advertiser," & "The Shifnal & Oakengates Advertiser".' The Crown Inn is on the right advertising Marston, Thompson & Burton Ales. In 1887 the landlord was taken to court and fined 24*s* 6*d* for selling intoxicating liquors on unlicensed premises.

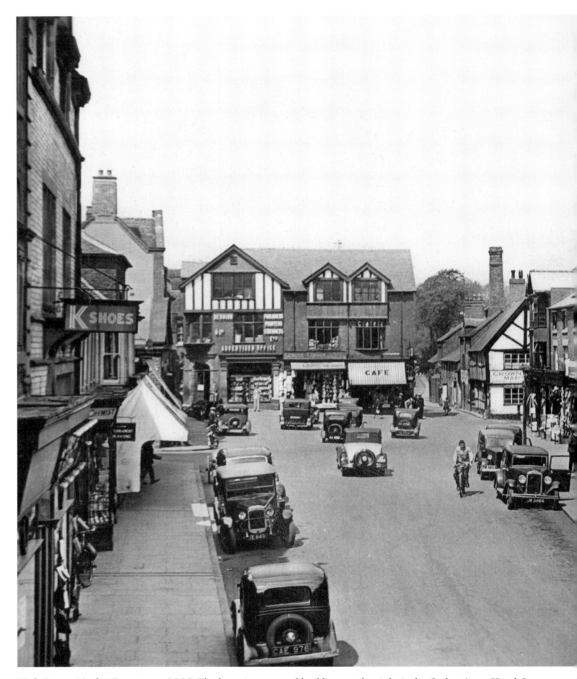

High Street, Market Drayton, *c.* 1935. The large ivy-covered building on the right is the Corbet Arms Hotel. It was named after one of north Shropshire's big landowning families and was first licensed in the eighteenth century. Thomas Telford lodged there in 1832 when the canal was under construction. The shop to the right was occupied by John Lockett, a bookseller, stationer, newsagent and printer. The building with the lights is an ironmongers belonging to Gouldbourn & Son Ltd. The business was started by Frederick Gouldbourn in the 1880s and also encompassed a grocery shop.

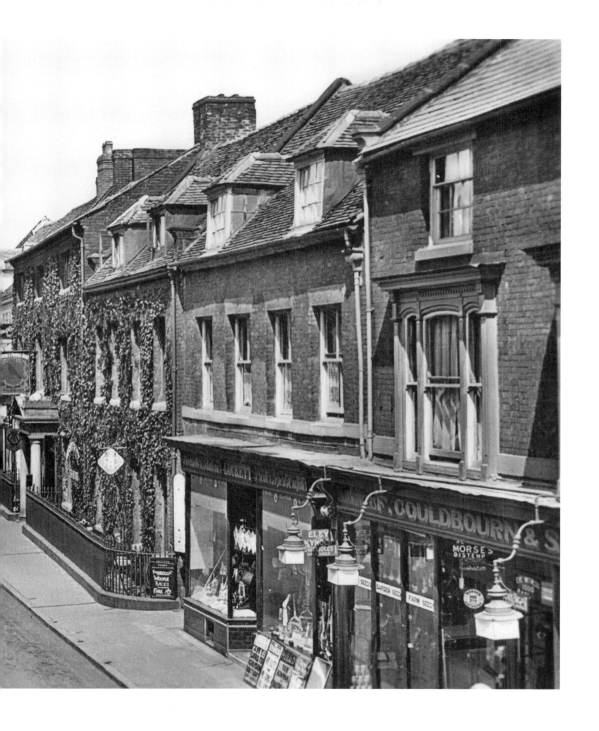

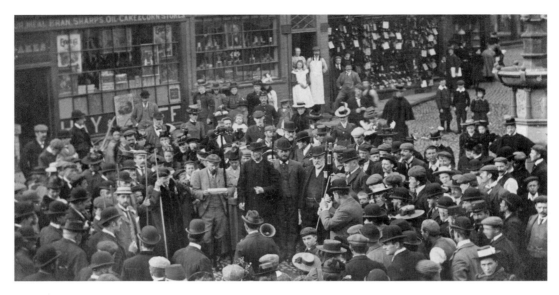

High Street, Market Drayton, *c*. 1903. This photograph was taken by Richard Arnold, a local photographer with a studio in Stafford Street. It shows the steward of the manor proclaiming the charter to hold a market or fair that had been given by Edward VII. It also allowed quarrels arising from the markets or fairs to be settled on the spot at the court 'pied poudre' where you appeared before the magistrate straight from the market with 'dust on your feet'. Mr Noden and his family watch the event from the doorway of his provisions shop.

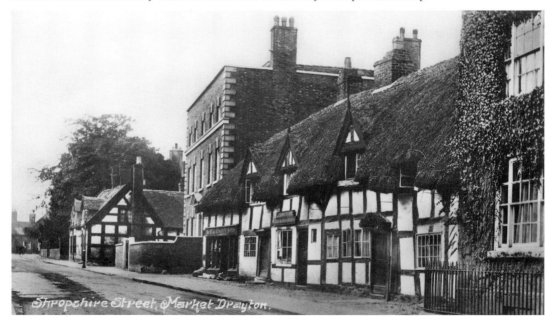

Shropshire Street, Market Drayton, *c*. 1920. The large Georgian house between the timber-framed cottages is Poynton House. It was built in 1753 for George Warren, a member of the Warren family who lived at Warren Court, a property to the left of the cottages at the top. The Warrens were solicitors and lived there for over 150 years. During the 1820s sheep-stealing was a major crime in the area and Charles Warren helped to apprehend one of the leading gangs known as the Bravos. After the trial, two of the gang were hanged and three were transported to Australia. Note the sign over the middle cottage belonging to John Darbyshire, a bootmaker, and the one next door advertising 'Ye Olde Grocery Shoppe'.

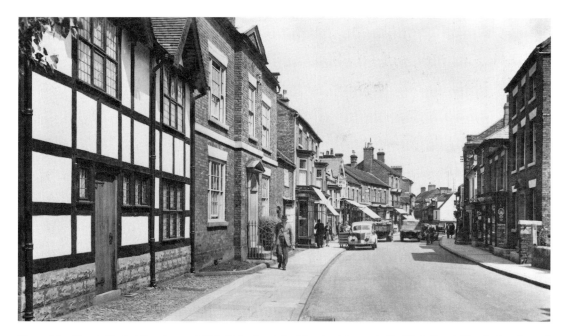

Shropshire Street, Market Drayton, *c.* 1950. This view is looking back towards the High Street. The timber-framed house on the left is a renovated and modernised section of some older thatched cottages on that site. The man is walking past Devon House. The low house next door once housed a florist shop run by Mabel Salter while just beyond is the chemist's shop belonging to Morgan & Co. The shop was later demolished when Frogmore Road was widened to provide an inner relief road.

Shropshire Street, Market Drayton, *c.* 1905. This view is looking towards the Shambles and the rear of the Meat Market. The picturesque timber-framed buildings were built soon after the great fire in 1651. The house with the railings and the name Sandbrook over the door was the premises of William Sandbrook, a wine and spirits merchant. In 1856 the house was occupied by Benjamin Bailey Sandbrook and the business was advertised as the Grape Wine and Spirit Vaults. The business continued well into the twentieth century until the house was converted into a public house called the Sandbrook Vaults. The building on the corner has been occupied by a butcher, a fruit merchant and a fishmonger before being converted into the National Westminster Bank in 1962.

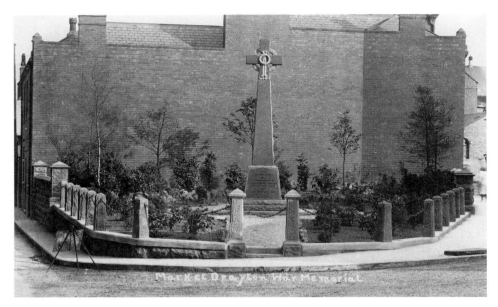

The Junction of Queen Street and Cheshire Street, *c.* 1921. The war memorial was dedicated by Lieutenant-General Chetwode on Armistice Day 1921. The local newspaper reported that, 'The monument is a grey granite cross on a massive base, approached by broad steps, the steps and sides of the cross being left unpolished, thus giving an effect of massive solidity.' It is 17ft in height and bears the names of 114 men from the Market Drayton area who gave their lives in the First World War. A small wall has since been erected at the rear of the memorial and the names of those who perished during the Second World War have been added.

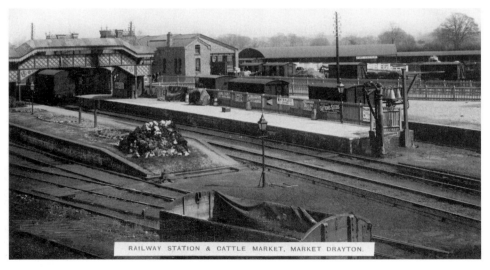

Market Drayton station and cattle market, *c.* 1911. A railway between Market Drayton and Nantwich was opened in 1863. The line was 12 miles long and cost around £50,000. A line to Wellington was opened in 1867 and another to North Staffordshire three years later. Just behind the building to the right of the footbridge is the goods shed and the cattle siding opened in 1878, where animals were unloaded for the cattle market on the extreme right. The cattle market was opened in 1872 and sales were held there every Wednesday until the market moved in 1993. The station was closed to passengers on 9 September 1963.

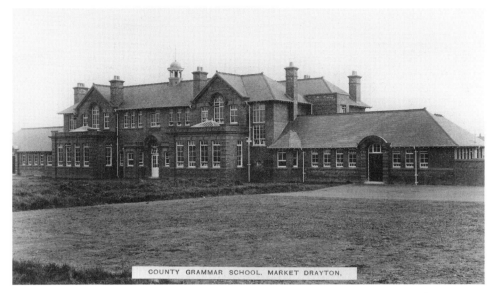

COUNTY GRAMMAR SCHOOL, MARKET DRAYTON,

Market Drayton Grammar School, *c.* 1912. The school was founded by Sir Rowland Hill in 1554 on land to the south-east of St Mary's Church. Its most famous pupil was Robert Clive, later Lord Clive of India, who studied there in the 1730s. The school moved to these new premises, built by the County Council, in 1912. For many years the boys and girls were taught in separate classes. In September 1965 the Grammar School merged with Market Drayton Modern to form a comprehensive school and until May 1995 this building was used as the first-year annexe.

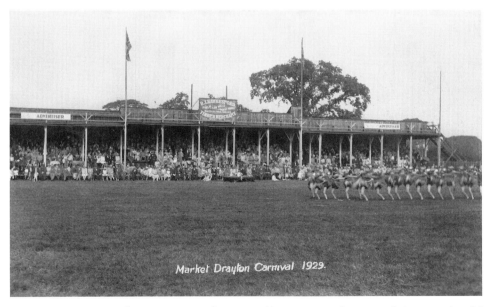

Market Drayton Carnival 1929.

Market Drayton Carnival, 1929. Between the two world wars, carnivals were at their most colourful and at the height of their popularity, with most big towns in the county organising their own event. It was agreed by many that the 1929 event at Market Drayton was the best since the war. The crowd are watching a performance by one of the jazz bands, which were a major attraction at all carnivals in the 1920s and '30s and competition was very fierce. The large sign over the grandstand is an advert for R.T. Hawkesford, a timber merchant in Station Road.

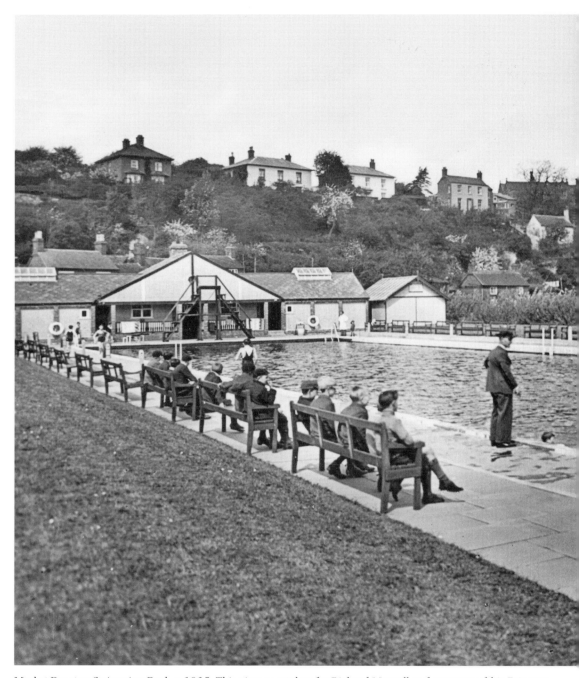

Market Drayton Swimming Pool, *c.* 1935. This view was taken for Richard Mansell and was part of his Princess series of postcards. Although unheated, the Olympic-size pool was very popular, attracting people from as far away as Stoke-on-Trent during their annual holiday known as Potters' Fortnight. The pool was opened in 1933 after Miss Onions donated £1,500 for the building of a public swimming baths. The complex later acquired a paddling pool and an ornamental fountain but was replaced with a heated modern indoor pool, which was opened in November 1995.

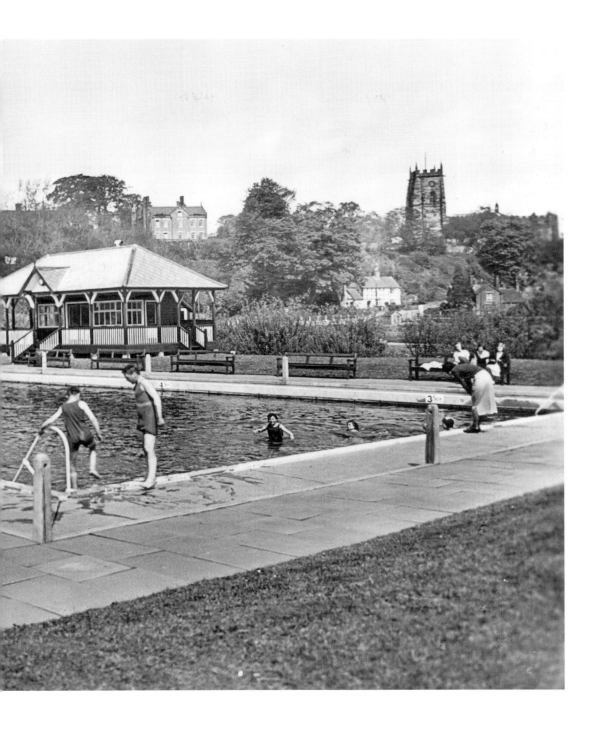

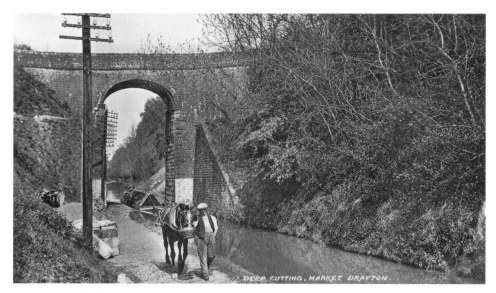

Deep Cutting, Market Drayton. c. 1920. Thomas Telford's spectacular deep cutting at Tyrley show the great difficulties he overcame. However, problems soon arose and the angle of its deep sides had to be reduced to prevent rock falls and landslides. The bridge is one of a pair on this section of the canal used to connect farmland on either side of the water. Note the horse feeding while still pulling the barge. Commercial barges, though in decline, were still using the canal into the middle part of the last century.

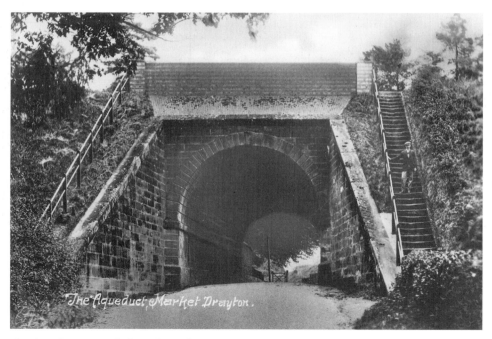

The Aqueduct, Berrisford Road, Market Drayton, c. 1930. After the deep cut there are five locks at Tyrley and within a short distance the canal passes over an aqueduct high above the road. The aqueduct was built by Telford and a flight of about sixty steps was needed to get from one level to the other. Today the road has been lowered to allow modern high-sided vehicles to pass underneath. The canal also passes over the River Tern, which passes through a culvert.

4

AROUND
MARKET DRAYTON

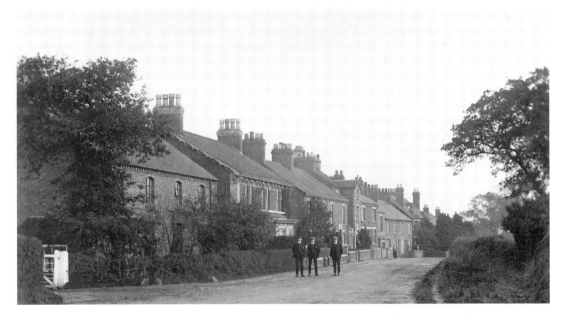

Pipe Gate, *c.* 1910. This tiny hamlet lies close to the Staffordshire border, a mile south-east of Woore. At the beginning of the twentieth century it was a busy place having its own post office run by Mrs Elizabeth Stone and a creamery owned by Henry Edwards & Son Ltd. There was a printing works run by John Fisher who was also a book binder, tobacconist and a dealer in tea and patent medicines. At the railway station James Meakin & Sons were dealers in coal, lime, salt and bricks and were wholesale paraffin merchants. The hamlet also had its own inn, the Chetwode Arms.

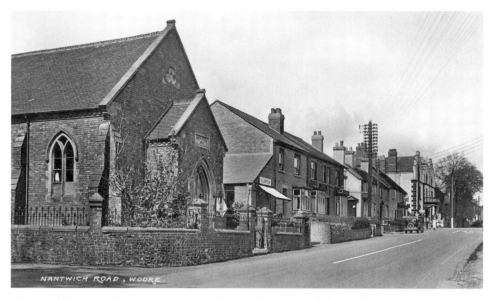

Woore, *c.* 1935. The village stands on the old Chester to London road, close to the borders of Cheshire and Staffordshire. It is claimed that the name of the village may derive from an old word meaning a border or from the old English for brushwood. This view is looking towards the Swan Hotel that was run at this time by William Mycock. The building on the left is one of two Methodist chapels in the village and was built in 1876. One was a Primitive Methodist chapel while the other was used by the Wesleyans. Next door is the butcher's shop belonging to Lawton Brothers, who had been trading there from the mid-1920s.

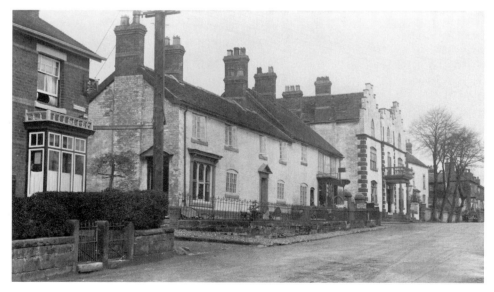

Woore, *c.* 1925. The building with the impressive doorway is the Swan Hotel, an old coaching inn. In 1896 it was owned by Thomas Henstock of Hanley, Staffordshire, and was managed by Anthony Ellwood. By 1901 it was owned and occupied by William Rhead. The house consisted of a bar and six rooms downstairs and fourteen upstairs with accommodation for twenty guests. There was also stabling for fourteen horses during the day and twenty-five overnight. In August 1899 the landlord was fined 40*s* and 27*s* costs for selling brandy to a drunken person. The house on the extreme left is the post office. The postmistress was Mrs Susan Simister and letters arrived in the village via Crewe.

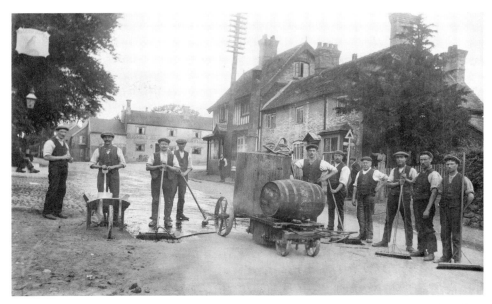

Woore, *c.* 1905. A road gang pose for the photographer as they spread tar over the road surface. One of the men informs us on the reverse that they had 'flit this morning and was in three different counties.' The building in the distance is the Cooper's Arms, one of the three public houses in the village. In 1901 it was owned by John Joules & Sons who were brewers from Stone in Staffordshire. The landlord was Thomas Jones who kept the inn clean and in good repair. In the top left-hand corner is the sign for the Falcon Inn. Opened in about 1800, it had a bar and a clubroom on the ground floor.

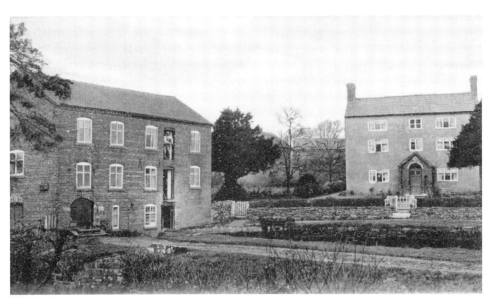

Bearstone, *c.* 1900. This small hamlet lies nearly 2 miles south-west of Woore. In *Kelly's Directory* for 1905, all the residents are listed as farmers except for James Matthews who was the local gamekeeper. The three-storey building on the left is a cornmill that was driven by a water wheel powered by the River Tern. There has been a watermill in the hamlet for several hundred years. In 1850 the mill belonged to George Bruckshaw who was listed as a farmer, maltster and corn miller but by 1885 the mill was occupied by William Hill.

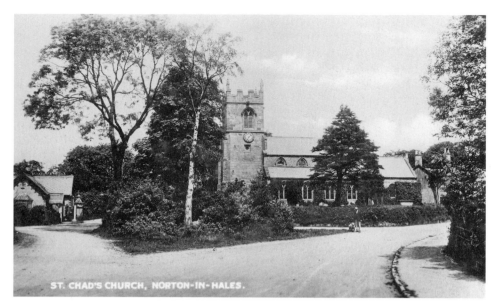

Norton-in-Hales, *c.* 1925. The church is dedicated to St Chad and originates from Norman times, but has been altered and enlarged on several occasions. It was restored by the Victorians between 1864 and 1865 and in 1872 a north transept was added. In 1926 the living included a rectory, 4½ acres of glebe land and £186 a year. The living was in the gift of the Church Pastoral Aid Society. The card was sent by Annie, Elsie, Lizzie and Sally to Mr W. Jackson of Kent Bank. They report that 'This morning we went to Norton to see the church, it is lovely, so we thought we would send you a photo of it. When the clock chimes twelve it plays Home Sweet Home.'

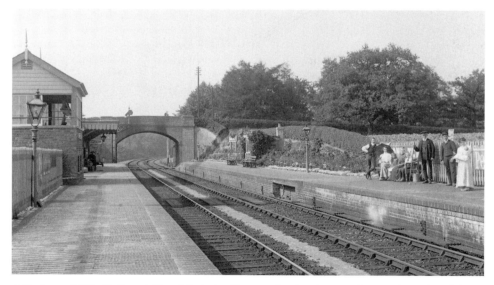

Adderley, *c.* 1910. Station staff and their families pose for the photographer on the right, while an elderly lady waits patiently by a pile of luggage on the left. The railway station stood on a section of line between Market Drayton and Nantwich. It was built by the Nantwich & Market Drayton Railway and was taken over by the Great Western Railway in 1897. It was one of two stations on the route, the other being at Audlem. The station was closed to passengers on 9 September 1963, although the line remained open to freight until 1967.

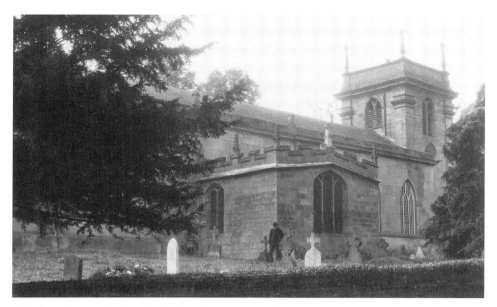

Adderley, *c.* 1910. The church is dedicated to St Peter and was described in 1913 as 'an edifice of stone in a debased modern style, consisting of chancel, north chapel, nave, transept and western tower with pinnacles containing a clock and three bells.' The Kilmorey chapel is the oldest part of the building, dating from about 1635. The tower was erected at the beginning of the eighteenth century while the rest of the church was built a century later in the Georgian style. In 1908 the building was restored at a cost of £900 and an organ chamber, reredos and rood screen were erected. The living was in the gift of Reginald Corbet and was held by the Revd Charles John Winser M.A. from 1900 to 1913.

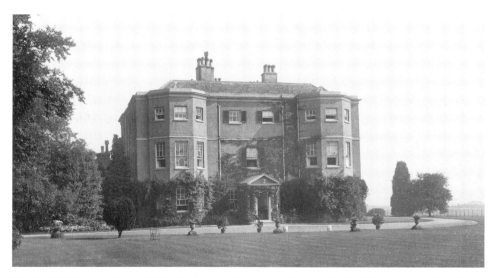

Styche Hall, Moreton Say, *c.* 1905. Styche was the boyhood home of Robert Clive who was born there on 29 September 1725. His father was a lawyer and he was the eldest of thirteen children. He went to India as a clerk for the East India Company but won fame and fortune as a soldier in the subcontinent, beating the French and gaining vast territories for the company. On his return he built this hall for his parents on the site of his birthplace. It was designed by London architect William Chambers and erected between 1760 and 1764. The portico was added in about 1796. In 1905 the hall was owned by the Earl of Powis and occupied by Lady Mary Herbert.

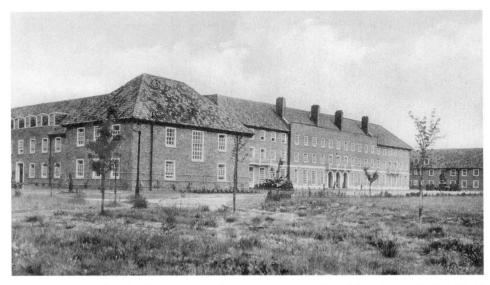

Tern Hill, *c.* 1939. These buildings are part of an RAF station established there during the First World War. This card was sent by A.W. Spratt 886328 from No. 3, W.O.M.Q., No. 10 S.E.T.S., Ternhill, Salop, to her parents in London in November 1939. She writes, 'Sorry I have not written before, very busy packing & transferring to above address. Please copy above exactly. A.W. stands for Airwoman. It's a grand place. We arrived yesterday and are living in barracks here. Altogether there are only eight of us here from Speke. Will write more fully tomorrow. Was vaccinated last Thursday. All O.K. Love to all Phyl.'

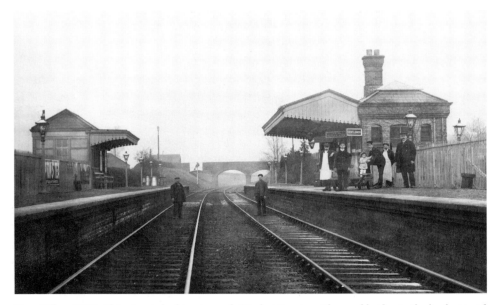

Tern Hill, *c.* 1905. This view is looking towards Market Drayton. The road bridge in the background carried traffic over the line on the main A41 between Whitchurch and Newport. The station was the third on the line between Wellington and Market Drayton, before it carried on to Nantwich. The station closed to passengers on 9 September 1963 and to goods traffic on the 10 August 1964. The main building with its ticket hall, ladies' waiting room and gentlemen's toilet are on the right. The stationmaster in 1905 was John Jordan, perhaps the man on the extreme right.

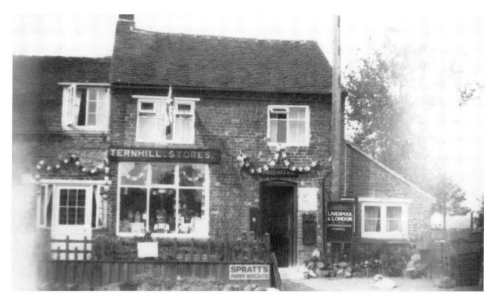

Tern Hill, *c.* 1930. The village shop was run for many years by George Adams. By 1929 Ternhill Stores was occupied by Miss May Weston who was also the sub-postmistress. Telegrams were received at the office but not delivered and letters were sent via Market Drayton sorting office. The front of the shop and the windows are decorated for some unknown event. The notice board to the right of the door informs us that the shop is the pick-up point for 'Liverpool & London & all intermediate towns'. Note the advert for Spratt's puppy biscuits on the fence and the little dog waiting expectantly on the forecourt.

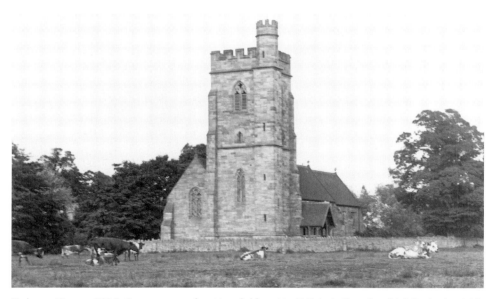

Stoke-on-Tern, *c.* 1915. Cows graze and rest in a field next to St Peter's Church, which lies just outside the village. This building was erected between 1872 and 1874 on the site of the old Norman church that had fallen into disrepair. It was designed by Charles Buckeridge who died in 1873 before the church was completed. It cost around £10,500 and consists of a chancel, nave, aisles, south porch, chapel and a tower that stands on the south-west side of the church. In the chapel is a fine tomb with alabaster figures belonging to Sir Reginald Corbet, a Justice of the Queen's Bench from 1559 until his death in 1566. The living was in the gift of his descendant, also named Reginald Corbet.

Childs Ercall, *c.* 1920. The village lies 6 miles to the south of Market Drayton. In 1920 most of the inhabitants worked on the land but there was a shop and post office, a school and a reading room, although no public house. The church on the right is dedicated to St Michael and has architecture dating from the twelfth to the fourteenth centuries. The church was restored in 1879 and a new pulpit and organ were given by the Revd J.P. Noble, a former vicar. The living is again in the gift of Reginald Corbet who is listed as 'Lord of the Manor'. In 1920 the vicar was the Revd Alfred Ebrey.

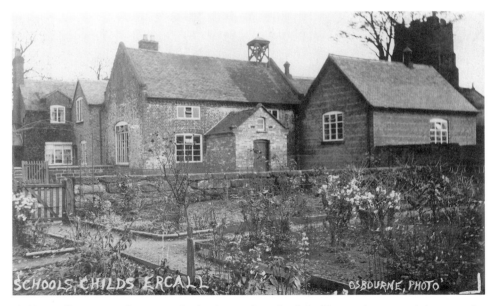

Childs Ercall, *c.* 1920. The National School was a large brick building with a master's house at the side. It was situated near the west side of the churchyard and in 1851 educated sixty-two boys and forty-two girls. The teacher at this period was George Hewitt who was also the Parish Clerk. By 1872 Mr and Mrs Mifflin were master and mistress of the school but by 1885 Mrs Mifflin had been replaced by her daughter Alice. By 1920 the master and mistress were John Slinger and Miss G. Brotherwood. Mr Slinger was also the assistant overseer in the village and honorary secretary of the village reading room. The school at this time taught an average of 140 children.

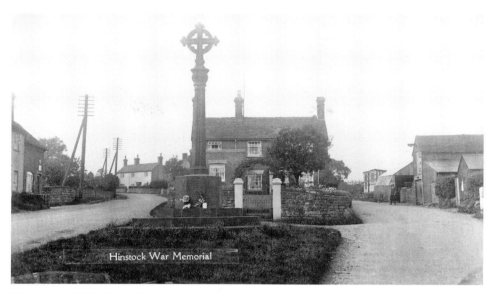

Hinstock War Memorial

Hinstock, *c.* 1920. The village lies just over 5 miles south-south-east of Market Drayton. In the Domesday survey the village is called 'Stock', which means a place. This view was taken after February 1919 when the war memorial was unveiled. It carries the names of eleven men who died during the First World War but just one from the Second World War. The building in the centre used to house a small sweet shop. The buildings on the right are part of Tudor's bakery, while the small house on the left is the shop and post office run by Mrs Mary Williams, the sub-postmistress.

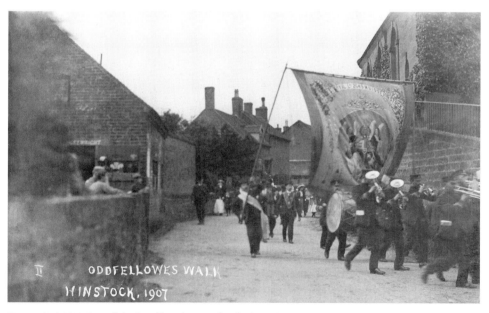

ODDFELLOWES WALK
HINSTOCK, 1907

Hinstock, 1907. One of the local bands precedes the large banner of the Hinstock Lodge of Oddfellows on their annual walk around the village and local countryside in 1907. The Oddfellows and other friendly societies were very popular at this time and often lodges from other villages would join the walk. They are watched on the left by a group of people in the yard of one of the village wheelwrights. There were two in the village at this period; George Beeston, who was also listed as a carpenter and joiner, and William Osbourn. Both were also listed as undertakers.

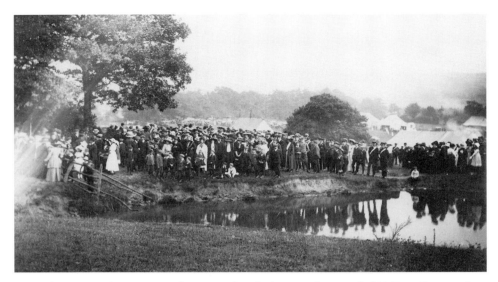

Hinstock, *c*. 1912. The caption on this postcard reads, 'Waiting the arrival of M. Hamel's monoplane at Hinstock Show'. This would date it to 18 July 1912 when Gustav Hamel gave a flying display to the crowds in his Blériot monoplane. Many people believed that this was the first time an aircraft had flown in Shropshire but they were wrong, as James Valentine had landed in the county almost a year earlier while taking part in an air race. The show originated in 1906 and as well as being a flower and horticultural show it also incorporated a sports meeting and dancing.

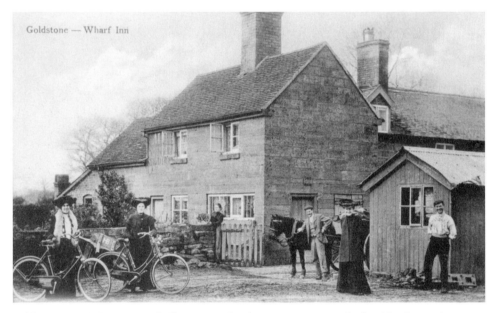

Goldstone, *c*. 1905. A group of villagers pose for the cameraman outside the Wharf Inn. The tavern was first listed at the beginning of the nineteenth century and in 1896 it was owned by Henry Belcher who lived at Gnosall in Staffordshire. There were three rooms on each floor and accommodation for two lodgers. The stables were undergoing repairs and there was accommodation for ten horses during the day but only five at night. The landlord was Edward Hanmer who kept the house clean and in good repair. In 1901 Mr Hanmer was still landlord but the inn had been sold to Pearce's Brewery of Market Drayton. The inn's custom came from agricultural workers and people passing by road or canal.

Cheswardine, *c.* 1950. This is a general view of the village taken from the steps of St Swithun's Church. The building to the right is the Fox and Hounds, an inn with a history dating back to the seventeenth century. In 1896 the inn was owned and occupied by Thomas Jackson who kept the house clean and in good repair. There were five rooms downstairs and nine on the first floor with accommodation for eight lodgers. In 1885 Mr Jackson was taken to court for allowing drunkenness on his premises. He was fined £2 9s 6d plus 10s 6d costs and his licence endorsed. By 1901 the inn had been bought by John Joule's brewery from Stone in Staffordshire. The landlord was William Ellis and it was reported that the inn needed painting and whitewashing.

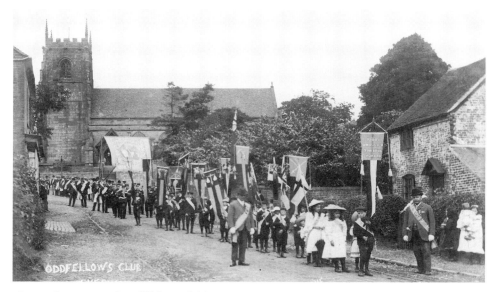

Cheswardine, 1908. The Oddfellows club line up outside St Swithun's Church before parading around the village. They are led by Lodge No. 4228MU Juvenile Branch. With the exception of the tower, the church was largely rebuilt between 1888 and 1889. The architect was J.L. Pearson who was also responsible for the rebuilding of the east end of Shrewsbury Abbey. The tower dates from the middle of the fifteenth century and has a string course below the belfry window with bosses depicting the Staffordshire knot and the Talbot dog, which is the emblem of the Earls of Shrewsbury. Carved on the buttresses are a lion and a griffin.

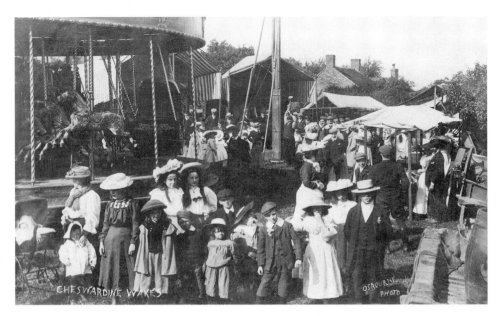

Cheswardine, *c.* 1910. A group of people, all dressed in their Sunday best, pose happily in front of the carousel during Cheswardine Wakes. In the centre background, a man raises a mallet in a trial of strength to ring a bell at the top of the pole. The event was celebrated on the nearest Sunday to St Swithun's Day, 15 July, and was held on a field that has now been built over. The Oddfellows walk was usually held on the same day.

Soudley, *c.* 1910. The name of this village, lying 6 miles south-east of Market Drayton, is pronounced Sowdley, which is probably derived from 'south field'. The building on the right with its entrance porch and arched windows is a Wesleyan chapel built in 1837. The house to the left is the village store that was run by Mrs Esther Hughes. Note the goods in the left-hand window. She also ran a boarding house as indicated by the message from Rose to Emmie Bate of Warslaw near Buxton. She writes, 'Just a line to say we are enjoying ourselves immensely. The weather is perfect and also the digs. This is a photograph of the house where we are staying.'

NEWPORT

Chetwynd End, Newport, *c.* 1910. This view is looking away from the town centre towards the roads to Eccleshall on the right and to Chetwynd Park on the left. The turning on the immediate left is Green Lane. The low house with the bay windows on the left is the King's Head, which was first recorded at the beginning of the nineteenth century. In 1896 it belonged to Richard Heane, a solicitor in the High Street, but was occupied by Benjamin Phillips. By 1901 it was owned by Newport Brewery and occupied by William Hawkins. In 1896 the inn needed cleaning and lime-washing, but by 1901 it was reported to have been in good condition.

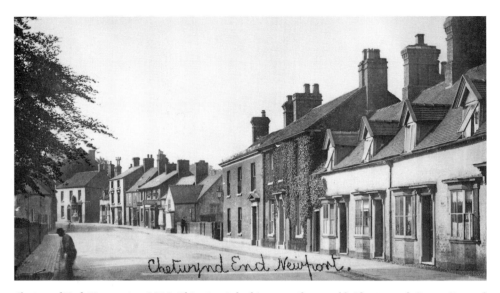

Chetwynd End, Newport, *c.* 1910. This view is looking over the canal bridge towards Lower Bar and the town centre. The shop at the top of the road on the corner of Salter's Lane was known as the Canister, owing to the large trade sign over the front window. The shop was owned by Joseph Vernon at this period, but from the 1920s until 1983 it was run by the Midgley family, who were famous for their large selection of cheeses. In modern times the buildings between Salter's Lane and the canal bridge have been demolished and replaced by a large petrol station.

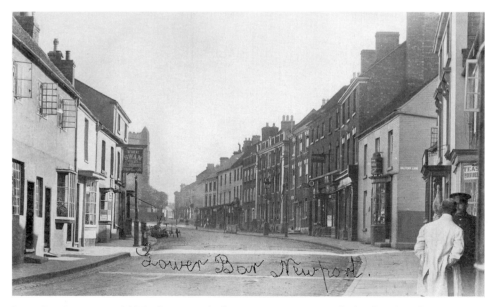

Lower Bar, Newport, *c.* 1915. This view is looking up Lower Bar towards the church and town centre. The canister can be seen over the shop window on the right by the corner of Salter's Lane. The garage just above the shop belonged to Richard Evans who was advertised as a motor repairer. On the left is the Swan Inn occupied by Henry Lodmore. The inn was owned by Lichfield City Brewery and had three rooms downstairs and six on the first floor. It was described in 1901 as needing 'renovating throughout' and that the stables needed lime-washing and new cratches and doors. Henry and his wife, Hannah, were tenants until about 1917 when Hannah became landlady of the Pheasant in Upper Bar.

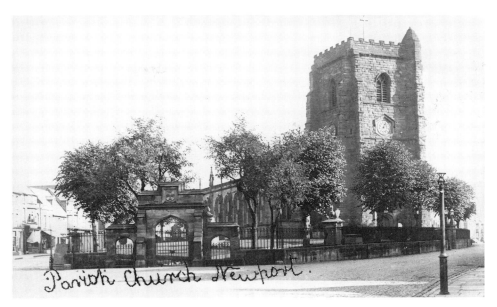

Parish Church Newport.

St Nicholas' Church, Newport, *c.* 1910. The parish church, which is dedicated to St Nicholas, the patron saint of fishermen, stands on an island between the High Street on the right and St Mary's Street on the left. The church dates back to the twelfth century. A chapel and chantry were established there in the fifteenth century by Thomas Draper, which survived until 1547. The tower dates from the fourteenth century but the main body of the church is Victorian; the chancel was restored in 1866 costing around £600, while the nave and side aisles were rebuilt between 1883 and 1891 at a cost of about £10,500.

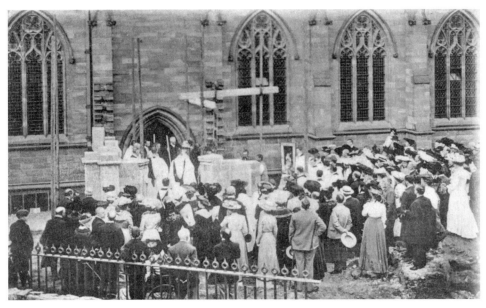

St Nicholas' Church, Newport, 1904. A large group of people gather to watch the foundation stone of the new south porch being laid. The porch was a gift from Lady Annabelle Boughey of Aqualate Hall, whose benevolence towards Newport was greatly appreciated by the locals. The sender of this card thanks Agnes Hughes of London for her postcard but writes, 'please excuse this one, it is the only one I have by me.'

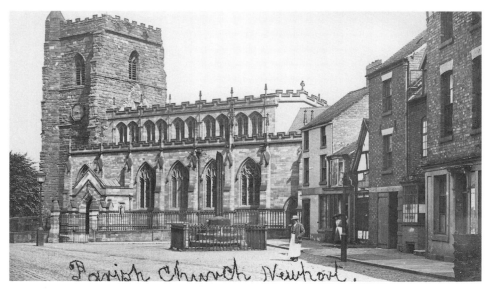

St Nicholas' Church, Newport, *c.* 1910. This view shows the new porch and the worn stonework of the tower compared to the smooth stone of the main body of the church. Also the outline of the original roof can be seen on the rear of the tower. The tower contained a clock with chimes and a peal of eight bells. The second shop on the right belonged to George William Adderley, a hairdresser who occupied those premises from about 1882 to 1934. The ladies to the right are standing outside the photographer's shop belonging to John Brown who was there from about 1900 until 1920. The pillar in the centre is the Pulestone Cross.

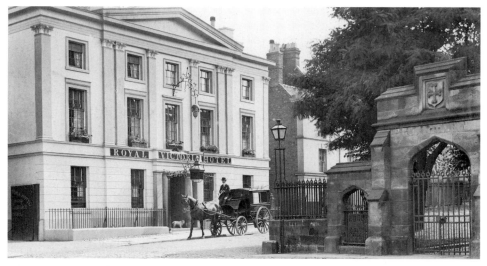

The Royal Victoria Hotel, St Mary's Street, Newport, *c.* 1900. The hotel was opened in October 1830 by a group of enterprising local businessmen who thought the town needed a first-class hotel. It was first known as the Union Hotel but after a young Princess Victoria and her mother took lunch there on the 27 October 1832, the name was changed to the Royal Victoria. Note the large bunch of wrought-iron grapes over the entrance porch. This has led to people thinking it was once known as the Grapes, but there is no evidence to support this. In 1901 the hotel was owned by the Victoria Hotel Co., Newport, who employed Patience Granger as the manageress. The hotel had eight rooms on the ground floor and seventeen on the upper floors. There was also stabling for twenty-two horses.

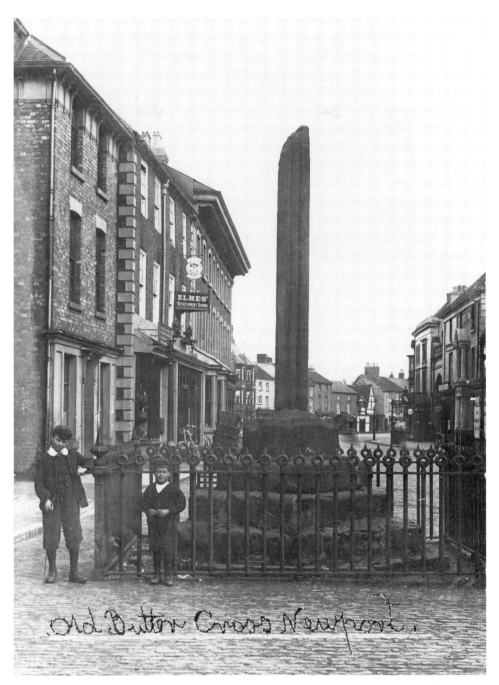

Old Button Cross Newport

The High Street, Newport, *c.* 1905. The Pulestone Cross was erected in 1272 in memory of Sir Roger de Pulstone who was killed in battle by the Welsh on Anglesey. The monument was damaged during the Civil War when the Celtic cross on the top was destroyed. The ornate metal fence surrounding it has been removed. Note the sign to the left advertising Elkes' refreshment rooms – Henry Elkes had a baker's shop in the High Street in the 1870s. At the beginning of the twentieth century the business was advertised as Elkes & Son bakers, confectioners and temperance hotel. By the outbreak of the First World War they were listed as bakers at 66 High Street, with another shop at 3 St Mary's Street.

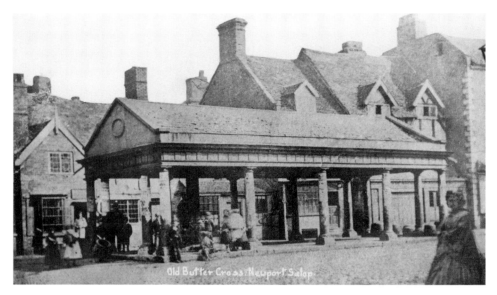

The High Street, Newport, *c.* 1855. The original Buttercross, built of wood, was erected on this site for the sale of dairy products in 1632. It was erected and paid for by William Barnfield but was destroyed in the town fire on 19 May 1665. This building of stone was erected by the Hon. Thomas Talbot and was open by November 1665. It survived for almost 200 years until it was removed in 1860 for road-widening. The pillars supporting the roof are believed to have been salvaged and used to embellish the front of the Vine Vaults that stood close by.

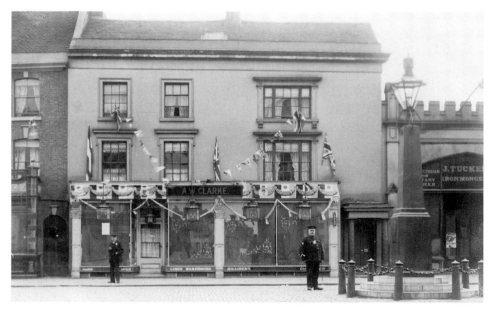

High Street, Newport, *c.* 1911. This view was taken by J. Symons of Newport, showing the decorations erected by the shop owner to celebrate the Coronation of George V. Note the portraits of King George and Queen Mary either side of the name. Arthur William Clarke was advertised as a draper at 53 High Street, he was there from the early years of the nineteenth century until the late 1920s. The ironmongers next door belonged to John Tucker who also had a storage area in Stafford Street. The large gas lamp-post is supported by the war memorial that was later removed to Station Road.

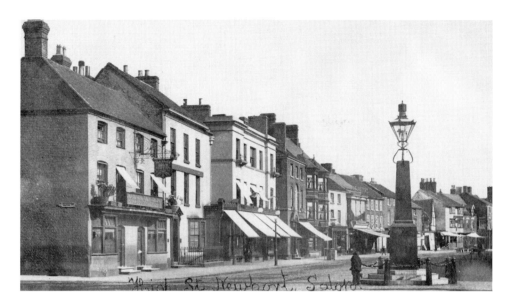

High Street, Newport, *c.* 1915. The building on the corner of Stafford Street is the Barley Mow Inn. It was first recorded at the beginning of the nineteenth century. In 1896 it was owned by the executors of the late James Doody, but by 1901 it belonged to T.F. Boughey Bt. The inn had six rooms on the ground floor and eleven on the upper floors. The stable had room for eight horses but needed a new manger and cratch and lime-washing. On 21 February 1893 the landlady, Miss C. Doody, was taken to court for keeping the inn open during closed hours but the case was dismissed.

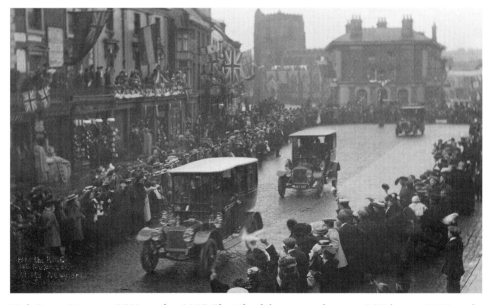

High Street, Newport, 25 November 1907. The title of this postcard sent on 25 February 1908 reads, 'H.M. the King 1st motorcar, visits Newport Salop.' Edward VII travelled through Newport to lunch with the Duke and Duchess of Sutherland at Lilleshall Hall. He had travelled through Stafford after visiting the Earl of Shrewsbury. It was a wet, miserable day as the nine-car motorcade drove through the town but hundreds of loyal subjects lined the route to catch a glimpse of their king. After lunch the king left by Royal Train from Newport station.

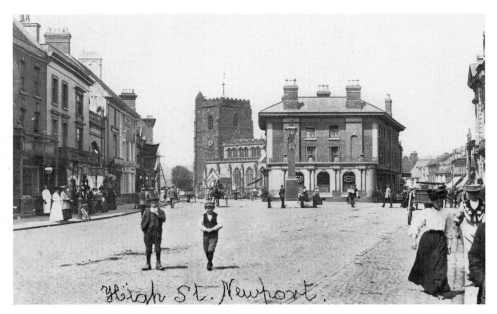

Newport, *c.* 1900 and 1930. Two photographs of the junction of the High Street and St Mary's Street with the church and the Vine Vaults in the centre. In the first view pedestrians walk down the centre of the road with no motorised traffic. In the second view all horse-drawn traffic has disappeared. The Vine Vaults dates from the early years of the nineteenth century. In 1896 it was owned by Messrs Addison & Lewis of Newport, who employed Charles Lewis as landlord. There were eight rooms on the ground floor and another thirteen upstairs. A survey in 1901 found that the ceilings and walls of the building needed papering and lime-washing. The Vine Vaults was replaced in 1966 by a typical 1960s building! The sign of a smaller inn, the Rose and Crown, can be seen on the right in St Mary's Lane. It was owned in 1896 by Peter Jackson of Stoke and occupied by John Arkinstall. It had two rooms on the ground floor and six on the first, but no accommodation for horses. The position of the gas lamp and war memorial is clearly seen on both views.

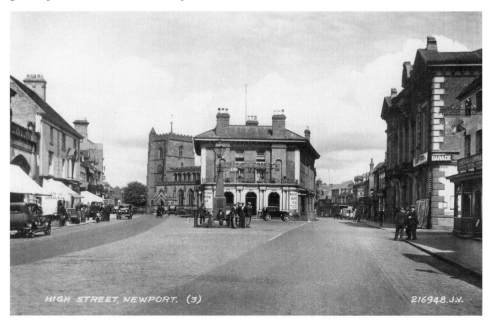

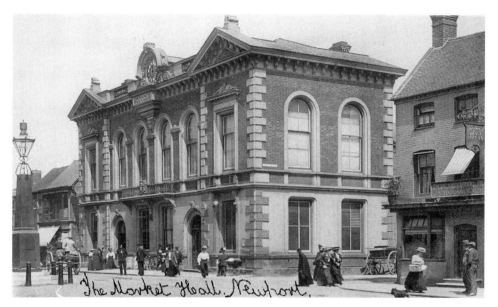

The Market Hall, Newport, *c.* 1905. The hall stands on the corner of Stafford Street and was designed by the architect J. Cobb in 1860. It cost about £13,000 and was paid for by the Newport Markets Company. It had two assembly rooms capable of holding 500 and 250 people and provided space for the town's general markets, held on a Friday. In the 1950s Nikolaus Pevsner described the architecture as 'debased Italianate' and many residents thought it an eyesore and a monstrosity. However, thankfully it was preserved and completely renovated in 1964. On the opposite corner is the Barley Mow.

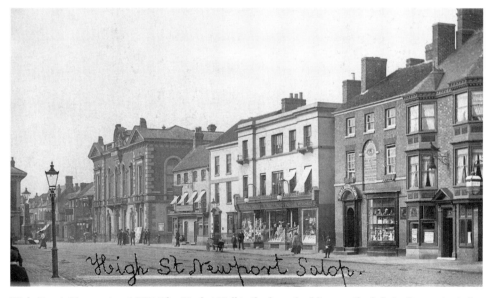

High Street, Newport, *c.* 1905. The Market Hall is the large building on the left. In the centre is the shop belonging to Richard Brittain, a wholesale grocer and provisions merchant who had other outlets in Wellington, Hadley and Shifnal. The shop to the right belonged to Chalmers & Son who were chemists and druggists. They were also opticians; note the advert in the arch between the windows on the first floor depicting a large eye and offering free sight tests. The building to the right is the Raven and Bell, sporting a fine inn sign over the front door.

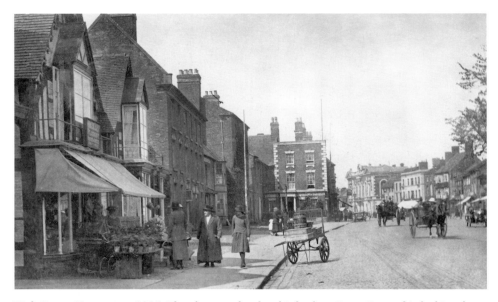

High Street, Newport, *c*. 1920. The photographer has his back to Upper Bar and is looking down the High Street towards the Market Hall. The shop on the left with its display of plants belonged to Thomas Blockley, a florist and fruiterer. His shop is at no. 1 High Street and he traded there from about 1910 to 1925. The building in the centre facing down the road is the National Provincial Bank, which was housed in that building before the end of the nineteenth century. In 1920 George Brampton was the manager. Immediately behind is the Trustees Savings Bank at no. 21. The sign by the gas lamp on the left belonged to the Old Bell Inn. The landlady at this time was Mrs Ellen Stanworth who took over the inn from her husband Daniel.

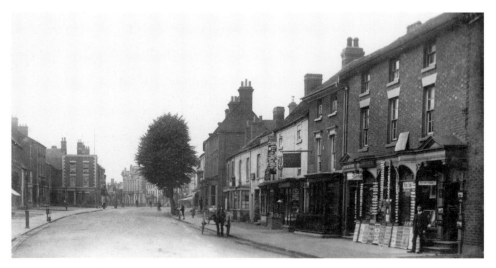

Upper Bar and High Street, Newport, *c*. 1910. The large newsagents belonged to Percy Cartwright, who also ran a post office and a picture-framing business. He had taken over the shop from Jabez Cartwright who was listed in 1885 as a tobacconist and in 1896 as a tobacconist, picture-frame maker and sub-postmaster. The business continued into the mid-1920s as Cartwright & Sons. The shop to the left belonged to Mrs Lucy Felton who was listed as a beer retailer in 1913 but as a pork butcher in 1917. Beyond are Elizabeth Armstrong's confectionery shop and a cycle business run by Alfred Breeze.

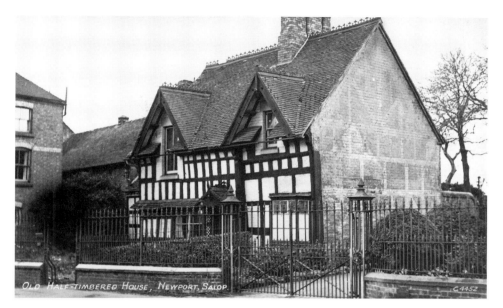

Upper Bar, Newport, *c*. 1930. This house is known as Smallwood Lodge. It dates from about 1600 with nineteenth-century alterations. It is a timber-framed construction with additional brick and plaster that has been painted to blend in with the timber-frame image. It was a private house for many years before being converted into a bookshop. Today it houses the Smallwood Lodge Tea Rooms.

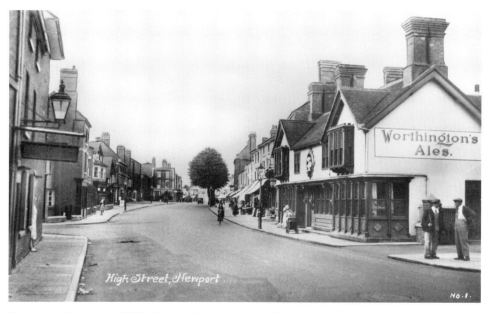

Upper Bar, Newport, *c*. 1930. This is a fine view of the Shakespeare Inn on the junction of Avenue Road. The road on the left is Wellington Road. In the census of 1896 it was reported that the inn was open before 1826. It was owned by a Shrewsbury brewer, George Jones Holt, and occupied by James Carrier Brown. The inn had four rooms downstairs and six on the first floor and was said to be in good order although the stables needed lime-washing. Five years later a similar report stated 'ceilings of passage, smoke-room and kitchen require lime-washing.' On 3 June 1890 the landlady, Mrs Elizabeth Williams, was fined £1 plus 6*s* costs for 'selling ale to a drunken man'.

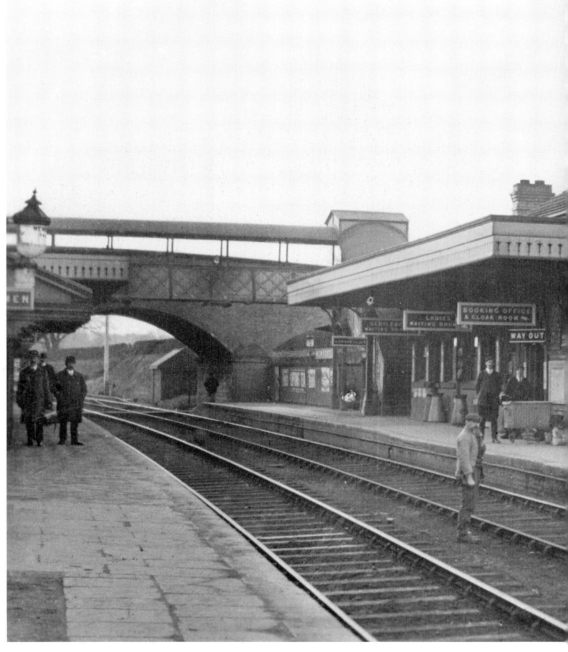

The railway station, Newport, *c.* 1905. The station stood on a line connecting Wellington to Stafford. It was started by the Shropshire Union Railways and Canal Company but was taken over by London & North Western which opened the line on 1 June 1849. Passenger trains passed through the station until September 1964 and goods traffic until 1966. A small section of line remained open until July 1991 to supply the military depot at Donnington. The station was later demolished and a housing estate built on the site. The man on the right is possibly the stationmaster, Thomas Smith.

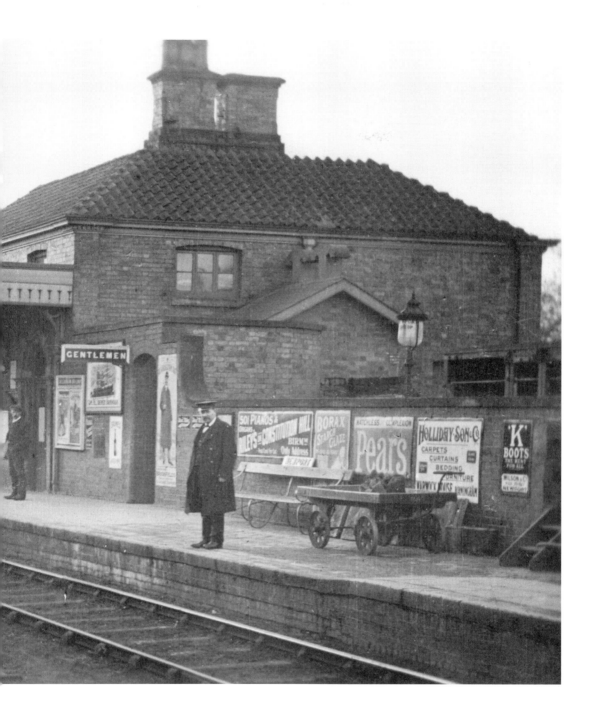

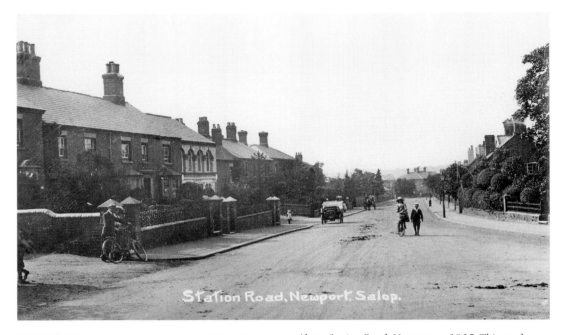

Station Road, Newport, Salop.

CATHOLIC CHURCH, NEWPORT, SALOP.

Above: Station Road, Newport, *c.* 1925. This road followed on from Upper Bar to the railway station. There are some fine houses on the road and several prominent citizens, including Harold Ward Evans, a physician, surgeon and medical officer and public vaccinator for the No. 2 District of the Newport Union, lived there. The white house on the left belonged to William Bow Dawson, a carriage builder, who ran his business from there. The business was first listed in about 1890 as Dawson & Son and was continued by Alexander Bow Dawson who transformed the business into a garage in the 1930s.

Left: The Catholic Church, Newport, *c.* 1920. The church, which stands on the outskirts of Newport, is dedicated to St Peter and St Paul. It was built in 1832 on the site of Salter's Hall, an old house belonging to the Earls of Shrewsbury. Bagshaw, in his 1851 directory, described the interior of the church as having 'a chase and elegant appearance; the seats or benches are all open and uniform in character, and the altar is richly carved and gilt; on each side of it are beautifully carved figures of the Blessed Virgin Mary and Joseph. The Windows on each side of the altar are adorned with representations of St. Peter and St. Paul, the patron saints of the church.'

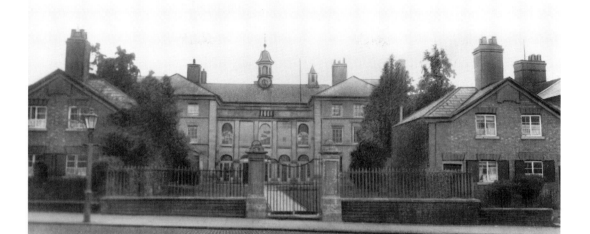

The Grammar School, Newport, *c.* 1930. The school was founded in 1656 by William Adams who was born in Newport in 1598. He went to London as a boy where he eventually became a member of the Company of Haberdashers and made a large fortune. The school was built on the site of the Booth Hall that housed the English School that Adams had attended as a boy. Adams played an active part in the running of the school and control of the school remained in the hands of the Company of Haberdashers until 1878. The school was largely rebuilt in about 1820 when the clock tower and cupola were added. A block of three new laboratories and classrooms to accommodate 300 were erected in 1929 when 250 boys were on roll; 60 of whom were boarders. Adams was also responsible for the building and endowing the almshouses on either side of the gates.

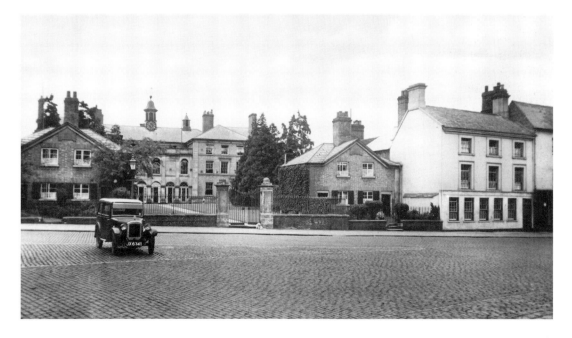

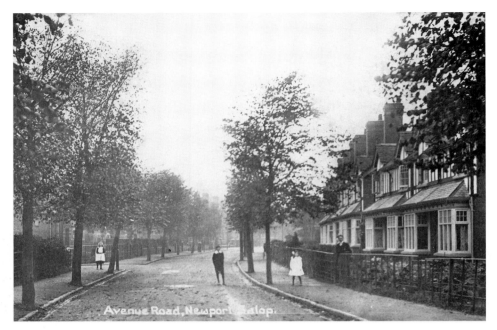

Avenue Road, Newport, *c.* 1912. This road, which leads to Upper Bar, was once known as Marsh Lane and was constructed in 1856. In 1869 a piece of land was given here for the building of a National School. It opened the following year amalgamating the National Girls' School that had opened in 1842 in Workhouse Lane and an infant school from Wellington Road.

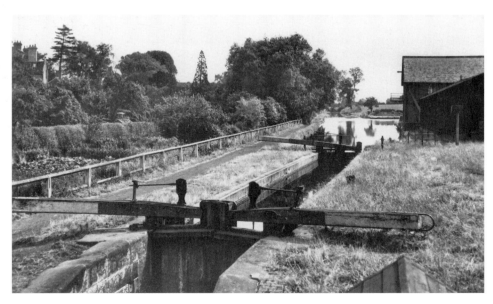

The Canal Bridge, Newport, *c.* 1930. This peaceful scene was taken from the canal bridge looking back towards Norbury Junction. The 10½-mile canal was built by Thomas Telford to link the Shropshire Union Canal to the Shrewsbury Canal. There was a flight of seventeen locks at the Norbury end of the canal and another six by Newport. This is number twenty, the Newport Wharf lock. The building on the right is part of the wharf and has since been removed to Blists Hill where it is used as a sawmill.

6

AROUND NEWPORT

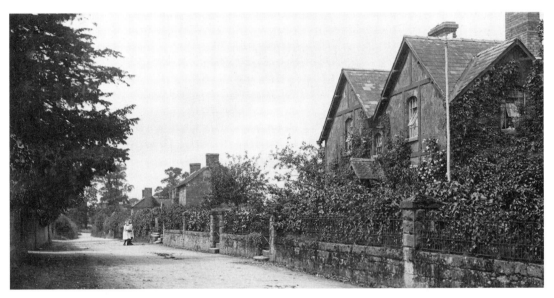

Sambrook, *c.* 1910. The village lies just over 4 miles north-west of Newport. It was a thriving little village with several shops, a post office and a school. In November 1914 this postcard was sent by Fred to Eric Jones of Lewisham, London. He writes, 'On this card will be seen a view of our "Borough High Street." You will just distinguish the P.O. chimney on the extreme left. It is very cold here today. Something like it was in 1916 when I was at the "Palace".' The post office was run at this time by the Tomlinson family who were also tailors.

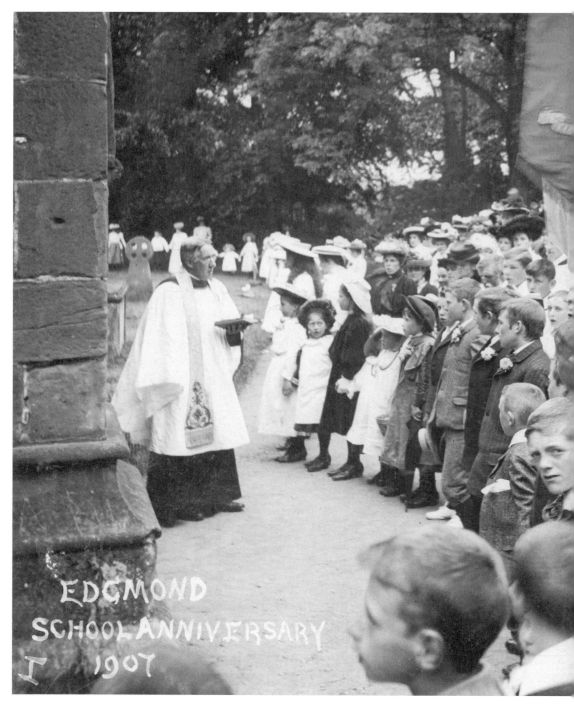

Edgmond, 1907. The school anniversary was held every year on Wake Monday. The people of the village have gathered to watch the children 'Clip the Church', an ancient custom where they all join hands to encircle the building. The custom had died out but was revived in 1867. While encircling the church, the clergy and congregation sing 'We Love The Place, O God'. The National School at Edgmond was erected in 1847 to accommodate 147 children.

74

High Street, Edgmond, *c.* 1930. The village lies on a small rise in the middle of flat countryside and its name is derived from Ecgmund's Hill. After the Norman Conquest the Manor of Edgmond lay in the hands of Roger de Montgomery, Earl of Shrewsbury, who gave it to the newly founded abbey in Shrewsbury. The two houses at the front stand on the corner of a crossroads. The road on the right is known as Robin Lane, while the one on the left is called Stackyard Lane. In 1934 the village had several shops, a post office, two public houses, the Lion and the Lamb, a reading room and Harper Adams Agricultural College.

Harper Adams Agricultural College, Edgmond, *c.* 1930. Thomas Harper Adams, who died in 1893, left a considerable amount of money and land for the establishment of an agricultural college. The college was built in the English Renaissance style and was formally opened in September 1901 by the Right Hon. R.W. Hanbury MP, President of the Board of Agriculture. The main objective of the college was, 'to give a thoroughly practical and theoretical training in agriculture and the sciences bearing upon the subject to those who intend farming at home or in the colonies, or who are qualifying as Estate Agents, for which purpose it is fully equipped throughout.'

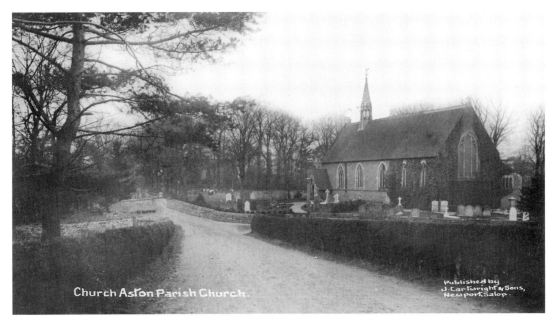

Church Aston, *c.* 1930. The village lies just a mile south-west of Newport. The parish church is dedicated to St Andrew and was rebuilt in 1867 from designs by G.E. Street of London. It was built out of red sandstone with white stone dressings. It consisted of a chancel and nave, a north aisle, south porch and a western turret containing three bells. Thirty men from this small village died in the First World War and their names were commemorated on an oak screen erected in their memory. In 1930 the church was in the gift of the rector of Edgmond and had been occupied by the Revd Thomas Edward Stevens since 1906.

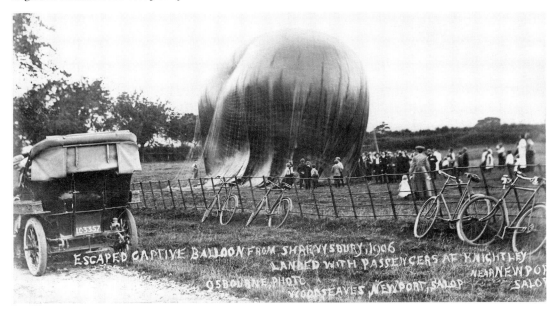

Gnosall, 22 August 1906. Captive ascents costing 5s were one of the highlights of Shrewsbury Flower Show at the beginning of the nineteenth century. But on this occasion the passengers got more than they bargained for when the balloon called *Wulfruna* broke free of her mooring and sailed halfway across Shropshire. It landed safely at Knightley Eaves near Gnosall. An untethered balloon ride like this would usually cost passengers around 50s.

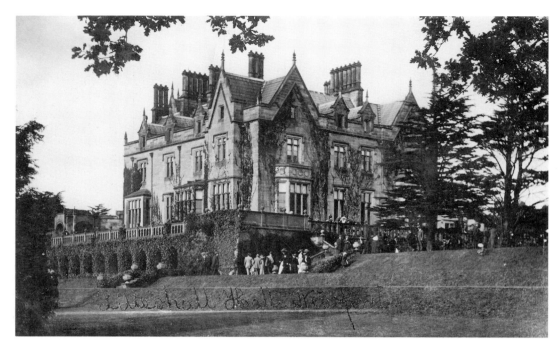

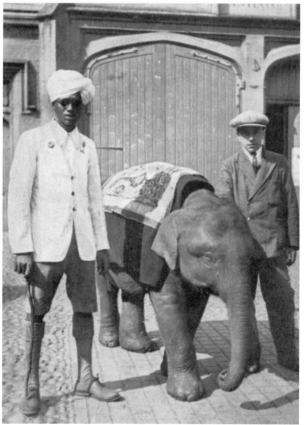

Lilleshall Hall, *c.* 1910 and *c.* 1925. The hall
lies 1½ miles from the village and was built
in 1829 by Sir Jeffery Wyattville for the Duke
of Sutherland. It was described in 1902 as, 'a
spacious and elegant mansion of white freestone,
in the Elizabethan style, and architecturally is
a splendid example of "the stately homes of
England." The house was erected mainly by the
Duke's tenant workmen, and the oak, which
forms so prominent a feature in the edifice, was
all grown on the estate.' The main approach
to the hall is by the Duke's Drive, an impressive
approach along a 2-mile avenue of trees. The
estate was sold in the 1920s and became a
pleasure park. The photograph of the baby
Indian Elephant and her handler was taken from
this time and was reported to have delighted
the children. The slogan for the attraction was
'See Lilleshall and know the thrill of living'.
During the Second World War it was occupied
by children from Dr Barnardo's before being
transformed into the National Sports Centre.

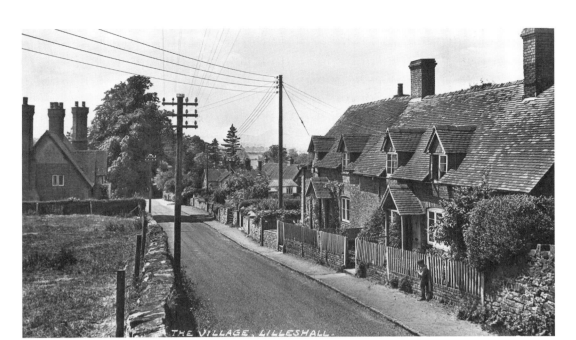

Lilleshall, *c.* 1930. The village lies just off the main Newport to Wellington road, 3 miles south-west of Newport. There has been a settlement there from Saxon times and the name is derived from Lilla's Hill. The village church is dedicated to St Michael and All Angels and was in the gift of Henry B. Rudolf of Manor Farm, Sheriffhales. In 1934 the village was mainly populated by farmers and smallholders but there was a shop run by Mrs L. Davies, the Red House Inn (occupied by Mrs Ann Watson), and a motor engineer called Eric Williams.

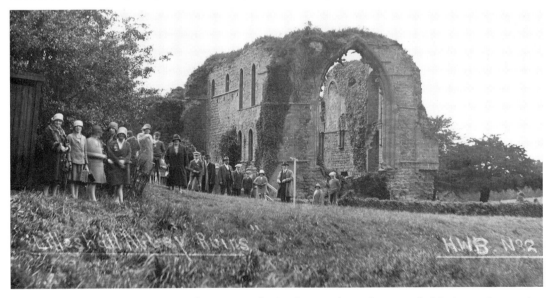

Lilleshall Abbey, *c.* 1925. A large party of visitors pose for the photographer at the east end of the impressive remains. The abbey was founded by two brothers, Richard and Philip of Belmeis, in about 1145. It was an Augustinian house, which had early links to the order of Arrouaise. The church was magnificent, measuring 207ft from the east end to the west door. The abbey was well endowed and owned many large holdings around the country. The abbey was suppressed on 16 October 1538 and sold to William Cavendish two days later. The last abbot was Robert Watson who received a pension of £50.

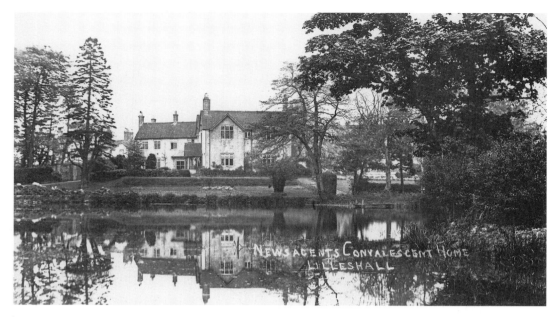

Lilleshall, *c.* 1935. Lilleshall Old Hall was once the home of the Dukes of Sutherland until the new hall was built in 1829. It was built in the seventeenth century next to a large pool that was once the fish pond belonging to the abbey. An extension to the right was built by Charles Clement Walker at the end of the nineteenth century. Mr Walker was a local JP and the author of *A Brief History of Lilleshall*. The hall was later owned by Robert John Milbourne before becoming a convalescent home for the National Federation of Newsagents, Booksellers and Stationers in the early 1930s. The first matron was Miss M.E. Palmer.

Honnington, *c.* 1930. The hamlet and pool lie three-quarters of a mile south-west of Lilleshall. The name Honnington is derived from 'the settlement where honey is made'. The house on the left is Honnington Grange. In 1885 Rowland Ralph lived and farmed there but by 1891 James Belcher had taken his place and continued to farm there until about 1922. By 1925 the Grange was occupied by H.A.L. Bayley who was secretary for C. & W. Walker Ltd, gas engineers, and also for the Lilleshall Gas Co. He had gone by 1929 and the house was occupied by C.T. Ward, who employed Thomas Spooner as his farm bailiff.

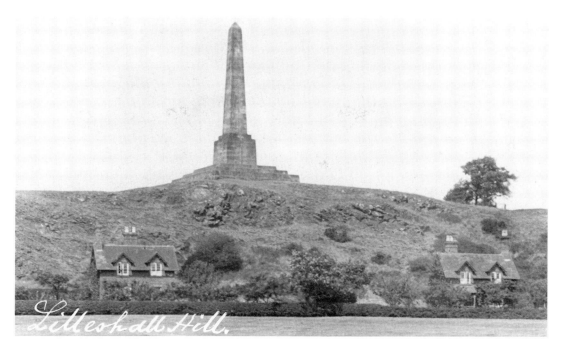

Lilleshall Hill, *c.* 1910. This is 'Lilla's Hill' that gave the village its name. From the summit there are fine views over the Shropshire Plain, the Clee Hills in South Shropshire, to the Breidden Hills in Wales. Sitting on top of the hill is a 70ft monument built in memory of George Granville Leverson-Gower, the 1st Duke of Sutherland. It was erected by his loyal tenants in 1839. The inscription reads, 'This monument was erected by the occupiers of his Grace's Shropshire farms, as a public testimony that he went down to his grave with the blessing of his tenants on his head and left behind him upon his estates the best inheritance which a Gentleman of England can bequeath his son; men ready to stand by his house, heart and hand.'

Eyton upon the Weald Moors, *c.* 1910. The village lies 2 miles north of Wellington. The place-name means a settlement on an island on the wild moors. The village smithy is on the right. At the beginning of the twentieth century the blacksmith was John Robinson who was also listed as an engineer, bicycle agent and repairer, motor agent and agricultural implement maker. Most of the inhabitants were farmers, but there was a watermill occupied by Watkin Jones, Arthur Hardy, the gamekeeper to Mrs Slaney-Eyton, and Edward Gough who was listed as a castrator!

Eyton upon the Weald Moors, *c.* 1910. The village did not have an inn, but it did have a post office and a small school. In the *Post Office Directory of Shropshire* for 1856 it states, 'There is a school for the children of Mr Eyton's cottage tenants, and which is supported by that gentleman.' By 1891 it was referred to as a 'Church of England School (mixed), built with teacher's residence and partly supported by T.S. Eyton Esq.' There were forty-one children on roll who were taught by Miss Selina Alice Cooper. The school closed in 1958 after the number of children on roll had fallen to ten.

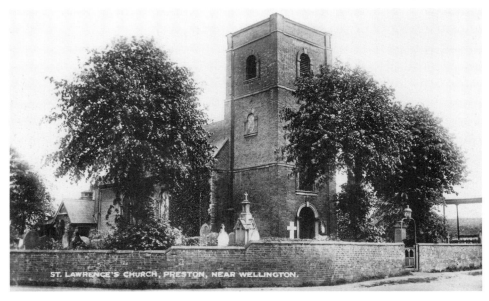

Preston upon the Weald Moors, *c.* 1930. The village lies 4 miles north-east of Wellington. In 1930 most of the inhabitants are listed as farmers although there was a wheelwright, a blacksmith and a small grocery shop run by Mrs Mary Pritchard. The church is dedicated to St Lawrence and is a small Georgian structure built out of red brick and erected between 1739 and 1742. It consists of a nave and tower with two bells and a chancel that was added in 1853. The Revd W. Houghton, a former rector and naturalist, wrote several fine books including a beautifully illustrated volume on British freshwater fish.

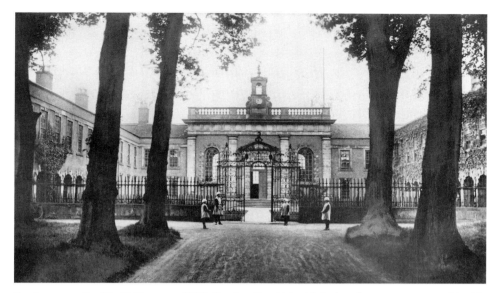

Preston upon the Weald Moors, *c. 1930*. Preston Hospital with its handsome entrance and highly ornamented railings was built as almshouses in 1725 to accommodate twelve poor women and twelve poor girls. They were richly endowed by Lady Katherine Herbert of Chirbury and her brother Lord Torrington; both children of the 1st Earl of Bradford. Later the hospital was enlarged to accommodate twenty women and twenty girls. The girls were aged between seven and sixteen and as well as being educated, they were trained to become domestic servants.

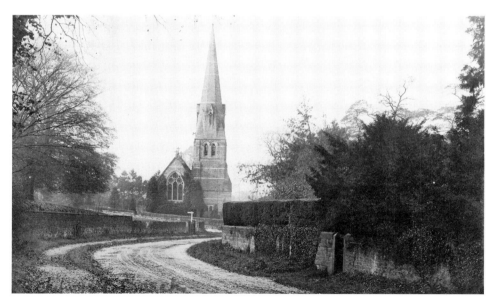

Chetwynd, *c. 1900*. The church is dedicated to St Michael and All Angels and is the fourth to have been built in the village. The first three were erected close to Chetwynd Park Hall but this one was built further away on the Chester road between 1865 and 1867. The architect was Benjamin Ferrey who built it in the Gothic style out of local red sandstone. There is a chancel, a nave of five bays, a south aisle, a north porch and a tower on the north side containing six bells and topped by an elegant broach spire. On the reverse Mrs Brown writes to Mrs Bateshiller, 'this is a view along one of our favourite walks – this road is now looking very pretty.'

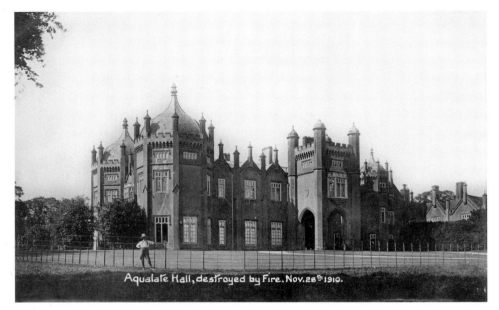

Aqualate, *c.* 1900 and 29 November 1910. The hall was described in Mate's book on Shropshire in 1900 as 'the seat of the Rev. Sir George Boughey, is a handsome mansion of white stone, standing in its own well wooded park, which is well stocked with deer.' Although mentioned in many Shropshire publications Aqualate is just over the border in Staffordshire but due to its location close to Newport it is perceived to be in the county. The second view shows the aftermath of a severe fire that started in the early hours of 28 November, gutting the hall and burning fiercely throughout the day and into the night. Note the firemen on the right damping down the following day with their hosepipe. The fire was discovered in the library shortly after 6 a.m. by Miss Lawton, the housekeeper. She informed Mr Butler (appropriately the butler) who with other servants tried in vain to contain the rapidly spreading fire with a hand pump. Some furniture and items of value were salvaged from the flames but one servant, George Harvey, was seriously injured when a floor gave way beneath him.

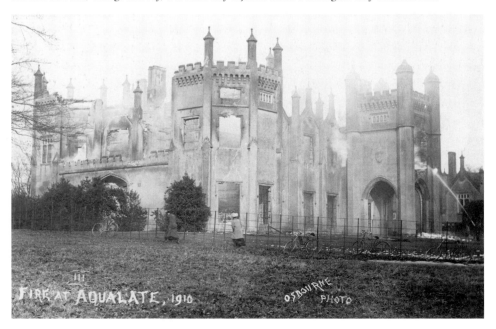

PREES & WHIXALL

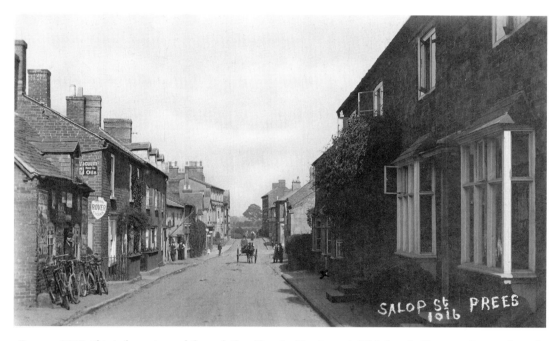

Prees, *c.* 1900. This is the main road through the village looking towards Whitchurch. The name Prees is derived from Celtic and means 'brushwood'. In the eighteenth century the village was an important coaching stop where horses were changed and travellers fed and rested and at one time there were twelve inns to cater for the coaching trade. At this period very little motorised traffic used the road but notice the bicycle shop on the left selling Vacuum Motor Car Oils and Imperial Rover Bicycles.

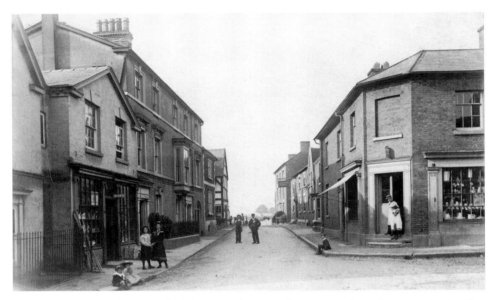

Prees, *c.* 1910. The children on the left are standing outside a grocery shop advertising Anchor Tea, while the shop on the right has a large array of crockery in the window and are advertised as agents for Berries Dye Works. Further down on the right is the sign of the New Inn, the last of the twelve that catered for the coaching trade. In 1875 the landlord was fined £1 and had his licence endorsed for supplying spirits to a boy under sixteen. In 1896 the inn belonged to Thomas Adams of Edgmond and was occupied by Sarah Dutton who kept the house clean and in good repair.

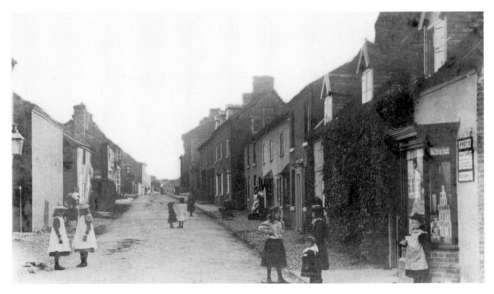

Prees, *c.* 1900. The photographer has taken a great deal of time to pose the children for this view along Shrewsbury Road. The shop on the right is the post office run at this time by Mrs Emma Davies. The office catered for all postal needs including money orders, telegrams, express delivery and parcel post. Letters arrived daily from Whitchurch at 6.50 a.m. and 4.30 p.m. and mail dispatched back at 8.55 a.m., 5.15 p.m. and 7.30 p.m. Mrs Davies also sold grocery and confectionery and ran a refreshment room and a touring cycling club. In the window is a poster for a fête advertising free treasure and sports.

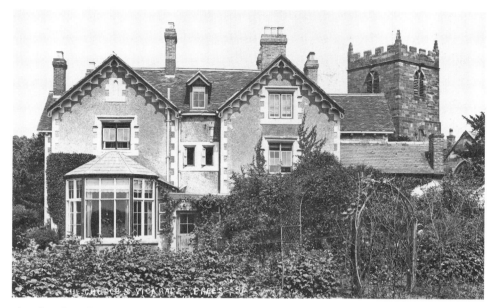

The Church and Vicarage, Prees, *c.* 1930. The church is dedicated to St Chad and dates from the fourteenth century. It was partly rebuilt in the seventeenth century and the tower was rebuilt in 1758. Further repairs were carried out in 1864 when the chancel was rebuilt, the roof retiled and the interior reseated. The Revd Llewelyn John Price became vicar in 1929 when the living, in the gift of the Bishop of Lichfield, was a vicarage and a yearly income of £635. The new vicar was also a Prebendary of Lichfield Cathedral. A former incumbent, James Fleetwood, later became Bishop of Worcester between 1675 and 1683.

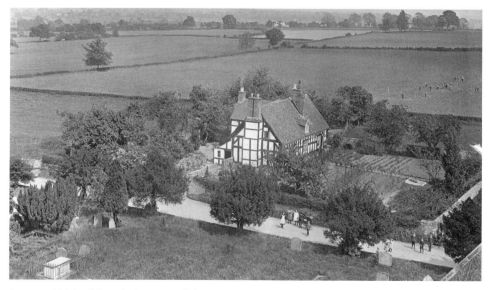

Prees, *c.* 1905. Although this view of the Manor Farm was an Edwardian postcard it was still being supplied in 1956 when it was sent to a Mr Huxley of Chelmsford in Essex. The view is from the church tower looking east; note the gravestones in the churchyard below. Today the house is called Manorhouse Cottage and has been reduced in size. The large chimney at this end has been removed but two dormer windows have been added.

Prees, *c.* 1900. The large complex in the centre is Prees Hall, which was owned by the Hill family. It dates mainly from the eighteenth century but parts are older. Shropshire's most notable soldier, Lord Rowland Hill, was born there in 1772. In 1885 it was the home of Colonel Richard Fredrick Hill but by 1891 the hall was occupied by Vere Francis John Somerset. He was succeeded by Captain Reginald Adam Black JP, who resided there for many years. The trees in the triangle were removed to make way for the war memorial in 1921.

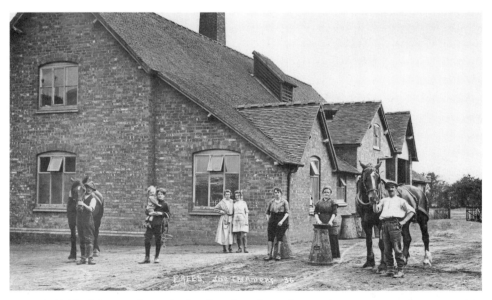

Prees, *c.* 1910. This view shows the family and workers who ran the creamery in Station Road. It was owned by William Horner, a dairyman, and was listed in *Kelly's Directory* between 1905 and 1926. The message on the reverse of this postcard is written in Danish and addressed to H. Thouisen in Denmark.

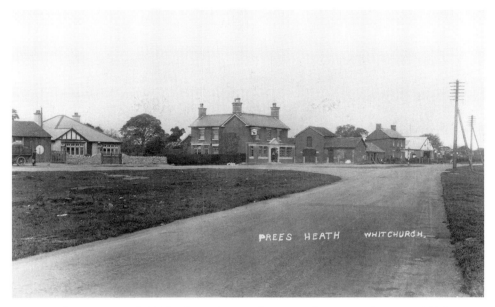

Prees Heath, *c.* 1920 and 1930. These photographs were taken across the main A49 between Shrewsbury and Whitchurch. The building in the centre of the top view is the old Raven Hotel. In the census for 1896 it was owned by William St John Hazledine of Shrewsbury. The licensee was William Saddler of Yew Tree Farm but the business was run by his wife Miriam, who in May 1896 was fined 1*s* 6*d* plus 18*s* 6*d* costs for selling beer to a drunken person. The old hotel consisted of a bar and three rooms downstairs and four on the first floor capable of offering overnight accommodation to six people. The new hotel was larger and extended to the left. The bungalow on the left in the first view can just be seen behind the white sign advertising the Breckland Café. The reason for these alterations and the addition of a number of cafés was the number of holiday makers from Birmingham and the West Midlands passing through on their way to the Welsh coast. As well as the Breckland Café, there was also the Yew Tree Café to the left, the Raven Café and the famous Midway Truck Stop. The Yew Tree Café was also a store and offered 'Express Service and the finest view'.

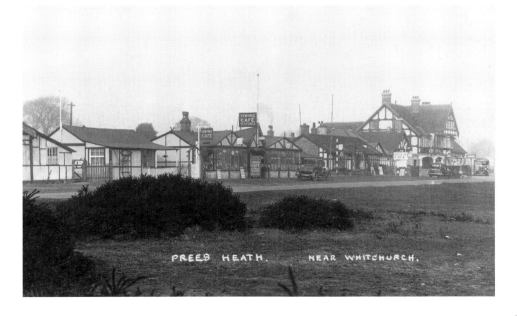

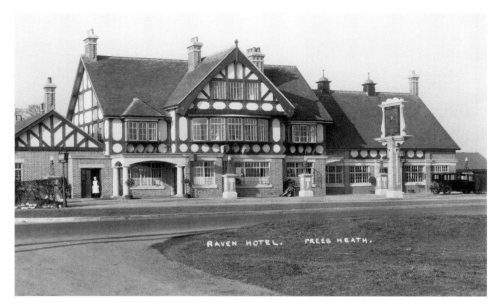

Prees Heath, *c.* 1930. The new enlarged Raven Hotel had a timber-framed upper storey and some fine brick and stonework on the ground floor. The sign in the foreground indicates the hotel sold Joule's Stone Ales and was AA and RAC recommended. On the Ordnance Survey map for 1972 it is named the Wild Raven Hotel. Note the maid with her white apron and cap standing on the left and the chauffeur attending his car on the right.

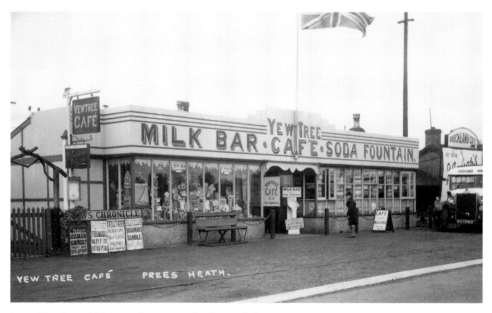

Prees Heath, *c.* 1930. By the 1930s the front of the Yew Tree Café had also altered but this was all superficial as the old building still stands at the rear of this modern façade. The café was AA recommended and advertised a milk bar and a soda fountain. The window on the left contains a fine array of confectionery, including Cadbury's chocolate bars costing just 2*d.* On the left the *News Chronicle*'s headline is 'Human Cargo! Great New Sea Story', while the *Daily Sketch* reports 'Franco's Reply to British Plan' and the *Daily Mail* reveals 'Bradman's Gamble'.

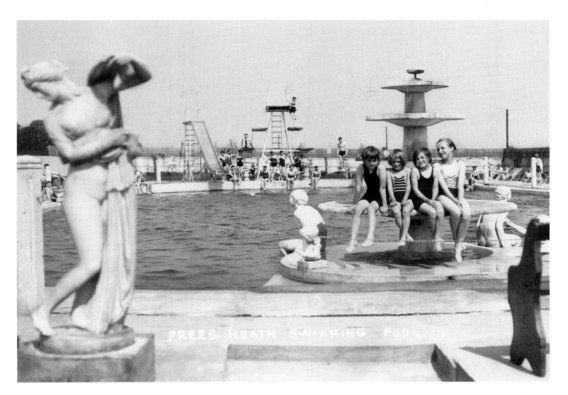

Prees Heath, *c.* 1930. This fashionable outdoor swimming pool was very popular with swimmers and sun-worshippers from a wide area during the summer months. Note the fine statue, ornamental fountain, the slide, diving platform and springboard in the 7ft 6in deep end of the pool. The pool was situated at the rear of the Witch Ball Hotel and was there until the 1960s.

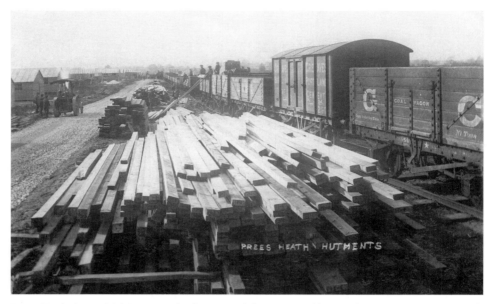

Prees Heath Camp, 1915. During the first year of the First World War a huge army camp was built comprising of hundreds of wooden huts. They were occupied by up to 30,000 soldiers from all over the country waiting to be sent to the front. This photograph was taken at the beginning of 1915 when timber was being unloaded for the erection of the huts opposite. Note the steam traction engine on the left. The message from Jim to Mrs Thomas of Lichfield on the reverse reads, 'The siding down the Ash Road by A.S.C. Stores.'

Prees Heath Camp, 30 January 1916. A group of carpenters pose for this photograph for photographer H.J. Watkins of Whitchurch. Note the two men on the left holding a plane and a hammer. One of the men, Will Brooks, writes to his mother at Cave Cottage, West Wycombe, 'Dear Mum, This was taken outside our hut we use as workshop. Monday dinner time it looks as though we were in the sun so we were. With love to you and the children, Will xxx.'

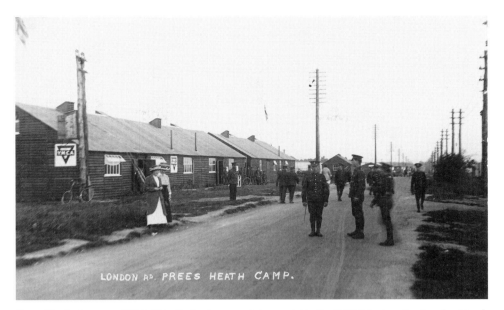

Prees Heath Camp, *c.* 1916. This lively view was taken outside the YMCA hut on the London Road. The message on the reverse from 'J.D. to Mr & Mrs T. Wilkinson' of Stockport reads, 'I send you this P.C. so you may see what kind of huts we live in and where I spend my leisure hours after my days work is done. It is very cold here now. We expect coming to Stockport soon.' After the war the camp was one of the main depots for demobilisation.

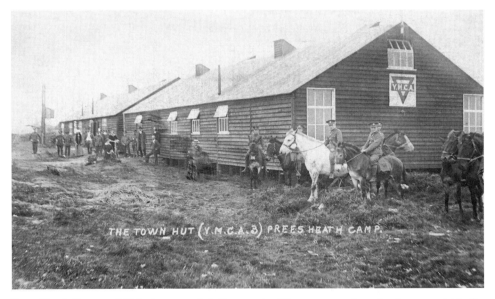

Prees Heath Camp, *c.* 1915. A group of civilians and soldiers, some on horseback, pose outside the Town Hut (YMCA 3). The message on the reverse from Will to 'Little Margery' Stonelake of London reads, 'This is the Y.M.C.A. hut, where I go sometimes in the evening. I had quite forgotten it was your birthday last Wednesday, and will wish you many happy returns of the day. Thank you very much for the mittens they keep my hands nice and warm.' After the camp closed all the assets were sold over several months by public auction. On 17 November 1920 lot items included seventy wooden and corrugated iron buildings, water service fittings, galley range stoves and boilers.

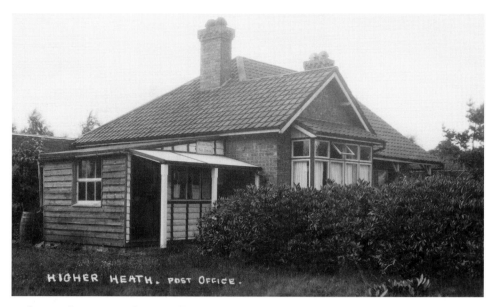

Higher Heath, *c.* 1930. The post office at Higher Heath was the little wooden shed built on to the side of the bungalow. In 1934 when this card was sent it was a call office dealing with just post and telephone calls. The nearest office dealing with postal orders and telegrams was in Prees nearly 2 miles away. The card from Auntie Nellie of Parkdene, Higher Heath, to Joan Mole of Bournemouth reads 'Do you remember this P.O? Auntie Gerty thought perhaps you would as you did several journeys to it whilst staying here.'

Prees Green, *c.* 1920. The village lies 6 miles south of Whitchurch, centred around the junction of the A49 and the B5065 to Wem. The hamlet was once part of Hawkstone Park Estate and many of the locals worked for Lord Hill. On the back of the card K.B. writes to Mrs Eldred who is holidaying at the C.A.W.G. Hostel in Llandudno, 'Very glad you are not camping as weather today, since 3, very wet. Hope you will get a good rest and change.'

Whixall, *c.* 1905. The village lies 6 miles south of Whitchurch just west of the A49. It is a large settlement scattered along a number of narrow lanes. The inhabitants were mainly farmers but there were several shops, four blacksmiths, two wheelwrights, two shoemakers a dressmaker, two tailors, two schools and two public houses. This building housed one of the two post offices in the village. The largest was run by Thomas Moore who was also a stationer and tobacconist. The second was in Platt Lane and was run by Mrs Sarah Jane Egerton whose husband Benjamin had a shop on the same premises.

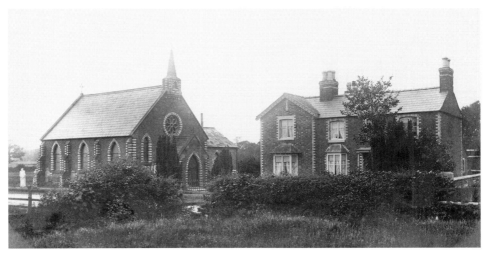

Whixall, *c.* 1905. During the nineteenth century religion played a big part in the life of the village. The church, dedicated to St Mary, was erected in 1867 at a cost of £3,000. Chapels were built for the Wesleyan and Primitive Methodists and also this fine Congregational church with its large manse in 1870. The building of the church was supported by the Massey family and gave seating for 140 worshippers. Set into the outside wall are several memorials predating the building. Three are dedicated to the Whitfield family and another to Ann Wakefield who died in 1828.

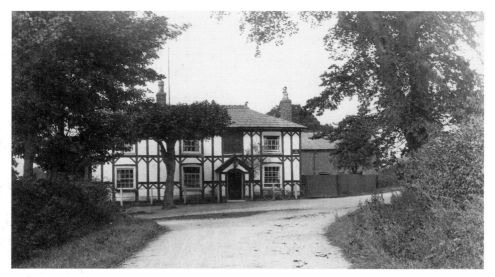

Whixall, *c.* 1930. In the 1901 census of public houses the owner of the Waggoners was Philip Phillips, a farmer and maltster from Green Lane Farm in Whixall. The inn, which was first licensed at the beginning of the nineteenth century, was managed by Mrs Jane Sale who had taken over the inn from her husband William. She is reported to have been a good manager, keeping the inn clean and in good repair. There was a bar and four rooms on the ground floor and five rooms on the first floor giving overnight accommodation for five guests. By the 1930s Thomas Plant was landlord who, note the sign on the extreme right of the first floor, had a car for hire.

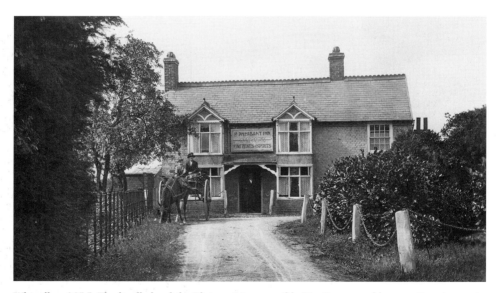

Whixall, *c.* 1915. The landlady of the Pheasant Inn, possibly Mrs Brown and her son Ernest, pose in the pony and trap, while a man stands in the doorway smoking a cigarette. The inn stood only 200 yards away from the Waggoners and was licensed around the same time. In the survey of inns in 1896 Mrs Susan Rogers was the owner and occupier. The inn had a bar and three rooms downstairs and four upstairs and was capable of accommodating twelve guests. In 1896 the inn was undergoing repairs but by 1901 it was reported to be clean and in good repair. On 26 May 1899 Mrs Rogers was fined 10*s* plus £1 2*s* costs for 'permitting drunkenness'. Fifteen months later she was fined 40*s* plus costs for selling 'adulterated spirits'. The sign over the door advertises Wem Ales and fine wines and spirits.

HODNET & HAWKSTONE

Hodnet, *c.* 1950. This is the main road through the village travelling from Market Drayton to Shrewsbury. The turn to Whitchurch on the A442 is on the right. The building on the left with the fine inn sign and the board on the pavement advertising lunch, tea and dinner is the Bear Inn. The Morris Minor is parked outside the shop belonging to William France, a tailor, and just beyond is the shop belonging to E. Taylor, which was later known as the Supply Stores when it was run by W.G. & F.M. Bennett.

Hodnet, 7 August 1916. In the 1901 census the Bear Inn was owned by the Heber-Percy family of Hodnet Hall but managed by Henry Thomas Groucott who kept it clean and in good repair. Facilities included a bar, smoke room and five other rooms on the ground floor, while upstairs there was an assembly room, ten bedrooms, a bathroom and two dressing rooms. The stable could accommodate sixteen horses by night but up to sixty by day. By the 1970s the inn was famous for its medieval banquets. In 1974 two bear cubs called Nuts and Crackers were bought from Scarborough Zoo to entertain guests but they did not respond to training and were sold.

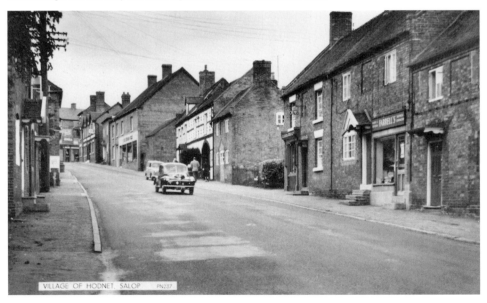

Hodnet, c. 1950. This view is looking up the main road towards the Bear Inn and Taylor's shop on the right. There are two shops in the bottom block of buildings on the right. The first is a chemist's shop, which in the middle of the twentieth century was occupied by James Naylor. Between 1882 and 1917 the chemist was William Cooke who was also listed in 1891 as a tailor, and deputy registrar for births, deaths and marriages. Later he also became the assistant overseer for the parish. The lower one is Farrell's grocery shop.

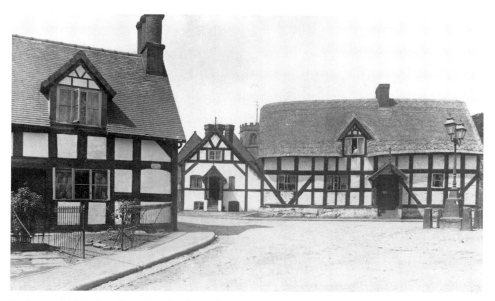

Hodnet, *c.* 1905. The village dates back to Celtic times and its name is derived from Hodnant, meaning 'a peaceful valley'. It huddles around the church and has many fine examples of timber-framed houses. The rare octagonal tower of St Luke's Church is visible between the houses. The fine thatched cottage in the centre is known as Ye Hundred House. For centuries the villagers elected their own coroner on the steps of this house and on fair days home-brewed beer was sold there. Note the young lady watching the photographer from the dormer window and the fine barleycorn chimneys on the roof to the left.

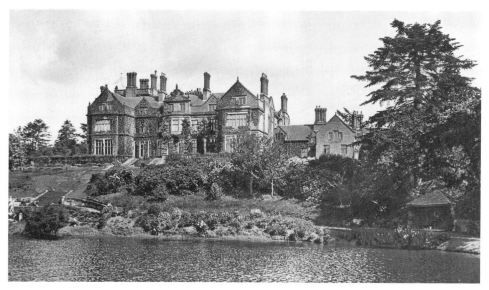

Hodnet, *c.* 1930. Hodnet Hall is the home of the Heber-Percy family. The present building was erected in 1870 and was modelled on Condover Hall by the eminent Victorian architect Anthony Salvin. In the foreground is the lake, which is part of the hall's extensive gardens that were laid out in the 1920s by Brigadier Heber-Percy. The 60-acre site, which includes several small pools, was constructed by the brigadier and three gardeners. The pools are all named and include the Heber Pool, the Pike Pool and the Paradise Pool. The house was later modernised by the removal of the top storey.

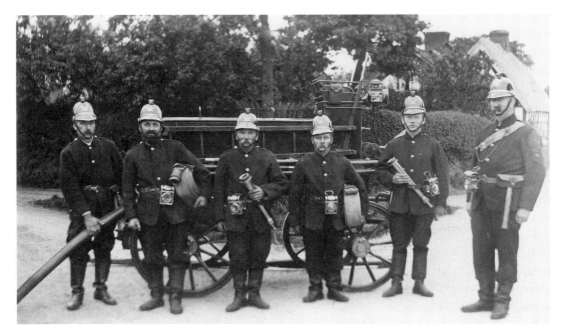

Hodnet, *c*. 1905. The Hodnet Fire Brigade pose in front of their horse-drawn fire engine. The superintendent of the brigade on the right is Robert Clunas who lived at the Hundred House. When fully manned the brigade consisted of nine men. The men are all wearing smart leather helmets that came into fashion when electricity was introduced into buildings, making the old brass helmets very dangerous. They are also sporting a variety of equipment including axes, lamps, hose reels and brass branches. Superintendent Clunas appears to be the only firefighter with a first aid badge on his left arm.

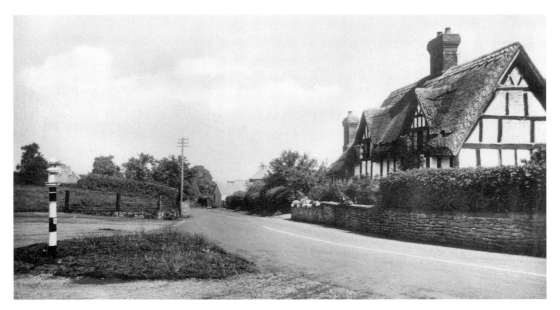

Marchamley, *c*. 1930. This small hamlet is situated 1½ miles north-west of Hodnet on the road between Wellington and Whitchurch. The hamlet contains a number of timber-framed houses and in 1930 most of the residents were farmers. There was also a shop run by Miss Ada Bryan and two shoemakers, Thomas Jones and John Davis. Mr Davis was also the sub-postmaster, receiving mail from Shrewsbury sorting office.

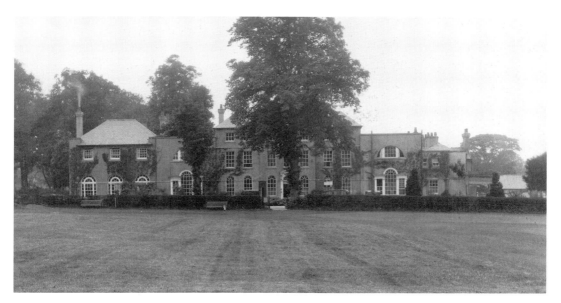

Hawkstone, *c.* 1930. The Hawkstone Hotel was built in the early years of the nineteenth century. An early record describes, 'The Hawkstone Inn, one of the most spacious and elegant Inns in the kingdom, more like the seat of a nobleman than a hotel.' By 1938 electric light, central heating and bathrooms had been fitted as well as a billiard room. A golf course and club house were located close by with green fees of 3*s* 6*d* a day or 4 guineas a year for men and 3 guineas for ladies. An advert recommended the country air as, 'a rare restorative for jaded energies, and over-wrought nerves, even in a sojourn of a few days.'

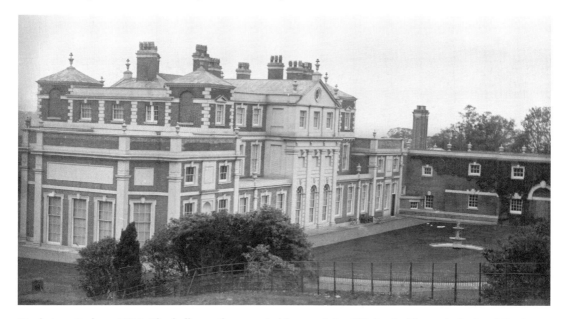

Hawkstone Park, *c.* 1915. The hall was the ancestral home of the Hill family. The main body of the house dates from two periods. The central part was built for Sir Richard Hill in 1722, and the wings by his nephew Sir Rowland Hill a quarter of a century later. It is built mainly of red brick with a stone dressing. A Catholic Missionary Order known as the Redemptionists bought the hall in 1926 and in 1934 erected a chapel, in the Romanesque style, to the rear of the south wing. Two rooms of note within the hall are the Venetian-styled saloon and the neo-Rococo ballroom.

Above: Hawkstone Park, *c.* 1910. Two cows graze in a field opposite a pair of cottages called Paradise. The 1938 handbook for Hawkstone informs us, 'The public have the privilege of admittance to the Park, every day (except on Tuesdays and before 12-30 on Sundays).' The guide also tells us that 'The office of guide has been held by the same family for at least four generations. The present senior, is know known as "Old Jones" having been in his father's lifetime distinguished as "Young Jones".'

Left: Hawkstone Park, *c.* 1910. A guide points out a feature of the park to a visitor that Pevsner describes as 'The ridge of sandstone cliffs, falling precipitously away south-west and south of the house and being guarded by sudden isolated crags, could not be more dramatic.' In 1938 tickets to view the park were purchased from the hotel and cost, 'Park, Red Castle Ruins And Obelisk . . . 6d. each person. Caves And Grotto . . . 6d. each person.'

Right: Hawkstone Park, *c.* 1910. The Obelisk is a Tuscan column built in 1795 to commemorate Sir Rowland Hill, the first Protestant Lord Mayor of London in 1549. The statue on top shows him in his Lord Mayor's robes, holding a copy of Magna Carta and is a copy of his monument that once stood in St Stephen's Church, Walbrook, before the Great Fire of London. A viewing platform at the top of the 112ft column can be reached by an interior stone staircase, giving visitors a wonderful panoramic view of the surrounding counties. The obelisk has been illuminated on several occasions including the arrival of General Lord Hill in 1814.

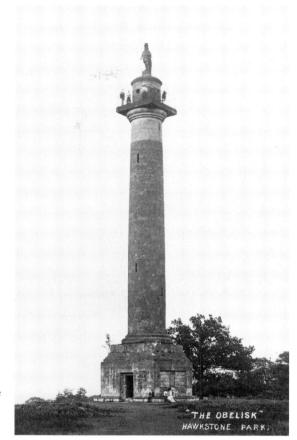

Below: Hawkstone Park, *c.* 1910. The windmill, minus its sails, stands north of the hotel on the bank of the 1½-mile long Hawk Lake. It is thought to have been built around the late eighteenth or early nineteenth century. The message on the back of the card from Edie to Gladys Smith in Prestwick reads, 'I expect you know where this view is. I came into the world here, it is my home. You can just see the house. It is very pretty don't you think. Love Edie.'

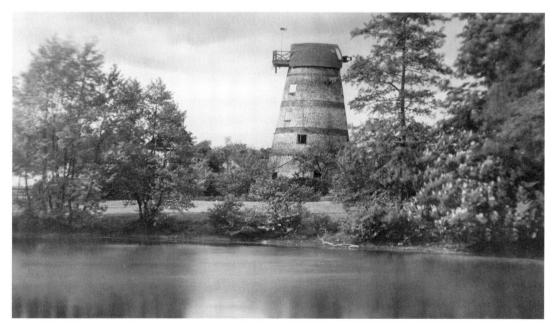

Left: Hawkstone, *c.* 1910. The Giant's Well was part of a genuine castle known as the Red Castle and built in about 1228. The castle, which once stood on two cliffs, was in ruins by the sixteenth century. It was reputed to have been the home of two giant knights called Tarquin and Tarquinus who were slain in battle by Sir Lancelot, a member of King Arthur's legendary Round Table. At the beginning of the twentieth century this tower was over a 100ft tall.

Below: Weston-under-Redcastle, *c.* 1910. The Citadel was erected in 1790 as a Dower House. In 1900 Mates described it as 'This stately residence, built of red sandstone, in the castellated style of architecture, stands upon a bold eminence. It was erected by Miss Jane Hill, sister of Sir Richard Hill, and Mrs Hill, wife of Colonel John Hill. The design of the house is copied from the family coat-of-arms.' It was once the home of Sir Beville Stanier who sat as a Member of Parliament for Newport and later for Ludlow. He died there in 1921 at the age of fifty-four.

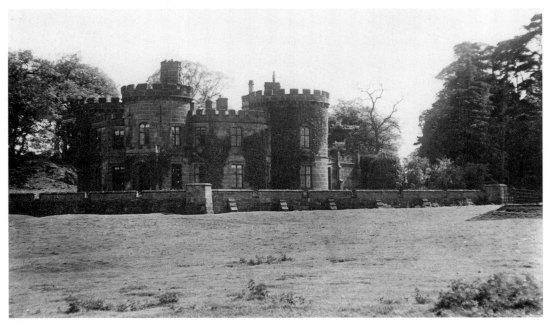

BETWEEN SHAWBURY & NEWPORT

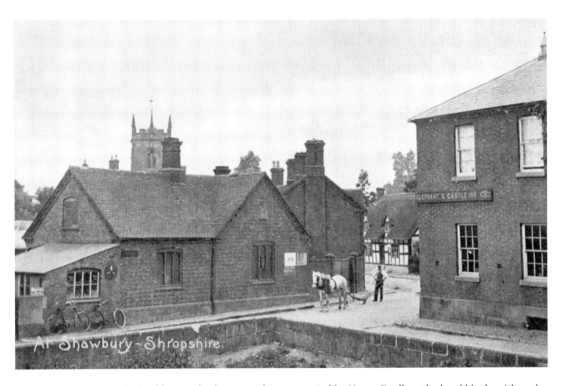

Shawbury, *c.* 1905. The building in the foreground was occupied by Henry Foulkes, the local blacksmith and implement maker, and William Foulkes, a bicycle manufacturer and sole maker of the Maypole Cycle. Note the man with the horse and plough on the right and the bicycles on the left. Henry established his business in the village in 1874 and was succeeded by William who continued to produce the Maypole Cycle. By 1929 William had expanded and advertised as a 'motor engineer & cycle maker; any make of car, cycle or motorcycle supplied, cars for hire.' The building on the right is the Elephant & Castle.

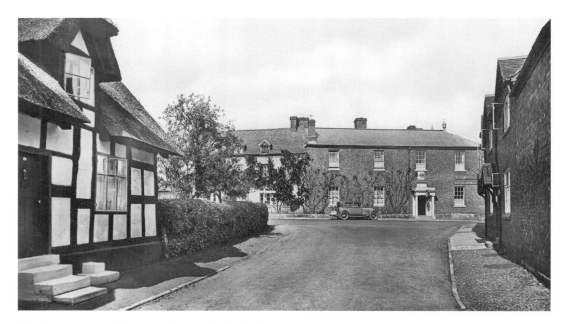

Shawbury, *c.* 1930. The car stands outside the Elephant & Castle. It was erected as a hotel by Sir Walter Corbet in 1734 and was originally a three-storey building with eighteen guest rooms and stabling for eighteen horses. In 1896 the owner of the hotel was Sir Walter Corbet of Acton Reynald. The licensee was Selwyn Hawkins and the hotel was occupied by Harry Hawkins. It had eight rooms on the ground floor, ten on the first floor and was reported as clean and in good repair. The Hawkins family were also listed as licensees of the Elephant & Castle at Grinshill.

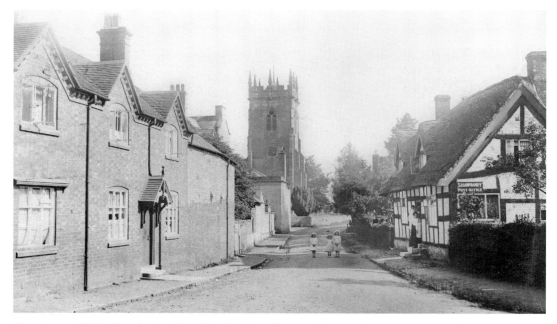

Shawbury, *c.* 1910. Three little girls and the family at the post office pose for the photographer. The postmistress at this time was Mrs Sarah Foulkes, probably the wife of William the maker of the Maypole Cycle. She was postmistress for about forty years. In 1910 the post office supplied a full range of services. In 1905 letters arrived daily from Shrewsbury at 7 a.m. except for Sundays when they were delivered at 10.45 a.m. Return delivery was at 6.15 p.m. The post office moved to a building next to the Elephant & Castle.

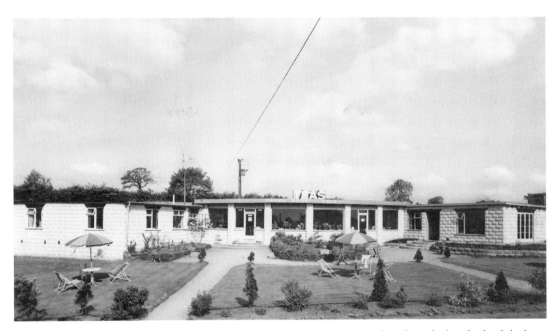

Cold Hatton, *c.* 1960. The village lies 6 miles south of Hodnet. The motel stood on the right-hand side of the busy A442 from Market Drayton to Telford. It was opened in the mid-1950s by Dick Williams who also opened Hill Top garage on the Dawley road out of Wellington. It was called Sandy Bank Motel and provided bed and breakfast, three-course dinners and teas. There was a large forecourt, garage and petrol station at the front. The motel was kept busy as parents visiting their sons at Wrekin College would stay there and the boys of the college were allowed to cycle there on Wednesdays. Mr Williams sold the motel in 1963 to a couple from the north of England. The motel closed and in June 1991 reopened as Hatton Court nursing and residential home.

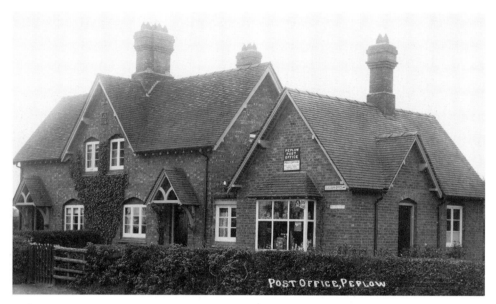

Peplow, *c.* 1920. Until the 1890s there was no post office in Peplow, only a post box that was emptied at 4.30 p.m. on weekdays. By 1895 William Haycock was employed as sub-postmaster. Letters arrived from Shrewsbury sorting office at 8.15 a.m. and mail was returned at 5.30 p.m. except for Sundays. Services included handling money orders and a savings bank, but if you needed to send a telegraph, Peplow railway station was the nearest office. By the 1920s letters arrived twice daily from Market Drayton but there was no delivery on a Sunday and the office was closed on Thursday afternoons. They also had their own telegraph system. The Haycock family were still running the post office and village shop in the 1940s.

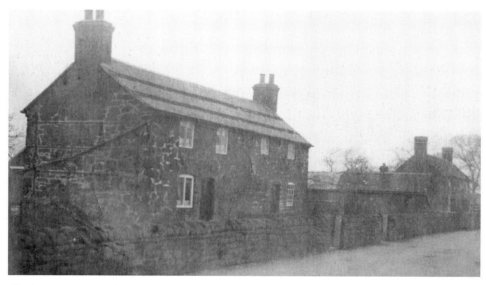

Ellerdine, *c.* 1910. In the nineteenth century Ellerdine was described as 'A township with a scattered population. The air is salubrious and the land has a fine undulating surface, the high ground of which commands extensive and interesting views of the surrounding country.' In 1913 most of the inhabitants worked on the land, but there was a shop and post office run by Miss Emma Barnett, William Ridgway, a blacksmith, and John Pickin, a well-sinker.

Poynton, *c.* 1930. In 1851 the hamlet was described as a 'small township in the parish of High Ercall, with a few scattered houses pleasantly situated on the turnpike road leading to Shrewsbury.' The 1841 census reports that there were twenty houses and ninety-five inhabitants living there. A century later, little had changed and there were only five entries in *Kelly's Directory* of 1929. They were Robert Atcherley, living at Poynton Villa, Tom Buttrey, a grocer, and three farmers. Note the barn on the left. The end gable is the west wall of a medieval chapel and contains a three-light Perpendicular window.

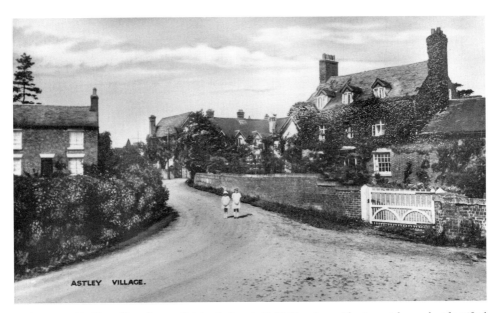

Astley, *c.* 1930. The village lies on flat land close to RAF Shawbury. The two girls can be identified as Gladys Bayley on the left and Doris Davies, who was about eight, on the right. The photographer took the view from the churchyard and he asked the girls to pose as they walked through the village. They were thrilled when the cards later appeared on sale at the post office. Gladys lived in the house on the right, which is now called Church House, while Doris lived around the corner at the top at The Hawthorns.

Hadnall, *c.* 1930. The photographer is looking down the A49 towards Whitchurch. The car is parked outside the New Inn that was selling Bass Burton Ales on draught. According to the census of 1896 it was first licensed as a beer house. In 1896 it was owned by T. Cooper & Co., brewers from Burton-upon-Trent. The landlady was Annie Kate Kewell who kept the house clean and in good repair. In December 1877 the landlord was fined 5*s* and costs for selling beer during prohibited hours and in September 1883 11*s* 10*d* plus 9*s* 2*d* costs for permitting drunkenness.

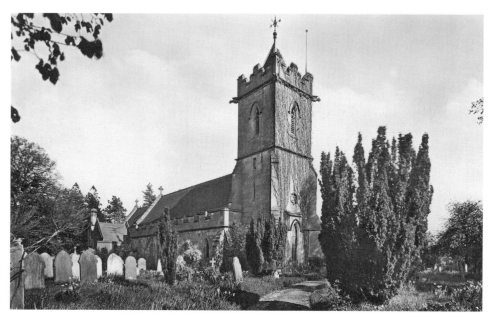

Hadnall, *c.* 1930. The church is dedicated to St Mary Magdalene and is a mixture of architectural styles dating from the Norman period right up to the Victorian era. It was once a chapel of ease to its mother church in Myddle, and it consists of a chancel, nave, south porch and western tower. A peal of tubular bells was installed in the tower, presented by Frank Bibby in memory of his parents. Beneath the tower is the tomb of Viscount Lord Rowland Hill, one of the Duke of Wellington's chief officers in the Peninsular War and at the Battle of Waterloo. He was Commander-in-Chief of the British Army from 1828 until his death in December 1842.

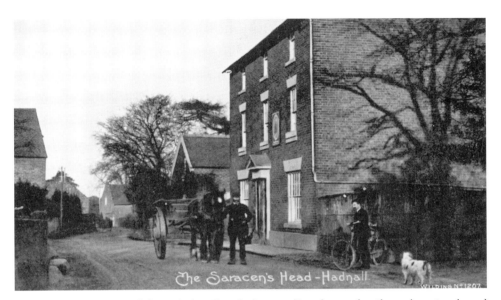

Hadnall, *c.* 1905. The road through the village looks more like a lane rather than a busy trunk road between Shrewsbury and Whitchurch. In 1896 the Saracen's Head on the right belonged to George Franklin Ward, who lived at Hadnall Hall. The landlord was Richard Evans who is reported to have kept the inn 'in fair repair and moderately clean.' There were five rooms on the ground floor and seven upstairs and stabling for five horses. Most of its trade came from agricultural labourers, passing travellers and a fortnightly auction that was held near the inn.

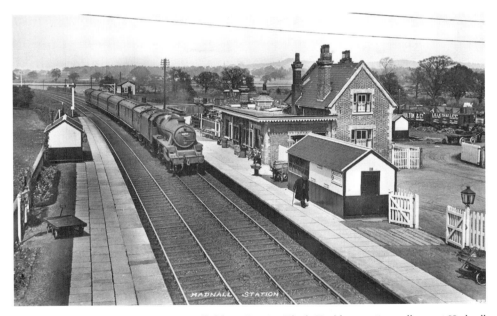

Hadnall, *c.* 1930. A passenger train pulled by a Stanier 'Black Five' locomotive pulls up at Hadnall station. The station stood on the Shrewsbury to Crewe line and was built by the LNWR before being taken over by the LMS. Hadnall, being one of the smaller stations on the line, was built of red brick with a yellow brick dressing, while the larger stations at Wem and Whitchurch were built in black. Note the advert on the right by the man, advertising Grocott's Ladies' Shop in Shrewsbury, and the wagons for the Lilleshall Company in the goods yard.

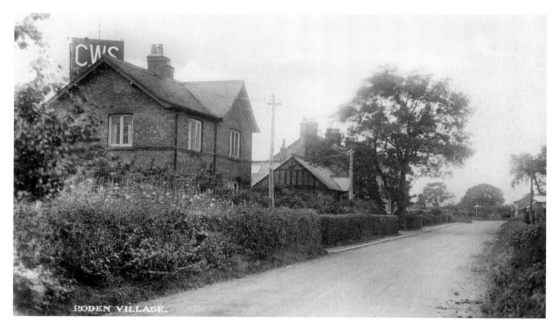

Roden, *c.* 1930. The photographer is looking towards Shrewsbury. The first house was occupied by John William Nowell, the manager for the Manchester Wholesale Co-operative Society; the society's initials can be seen on the water tower behind the house. Dan Leary writes on the reverse of this card in 1930, 'there are miles of glass houses grapes, tomatoes etc. orchards with I think millions of apples and gooseberrys every other row.'

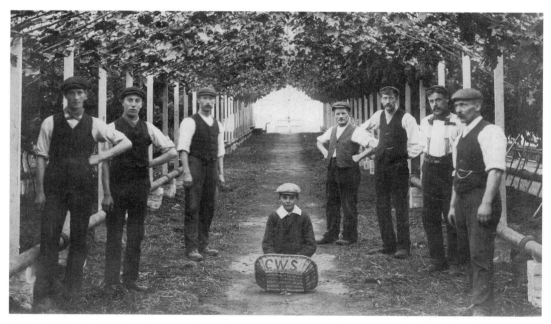

Roden, *c.* 1910. In 1896 the Co-operative Wholesale Society bought a 740-acre estate, which included a hall, three farmhouses and several cottages. At first 200 acres were farmed by the society while the remainder of the land was rented out. A great deal of the produce grown was sent back to factories in Lancashire, but just before the First World War a small jam-making factory was opened by the society in the village. This shows one of the greenhouses opposite the offices used for growing grapes.

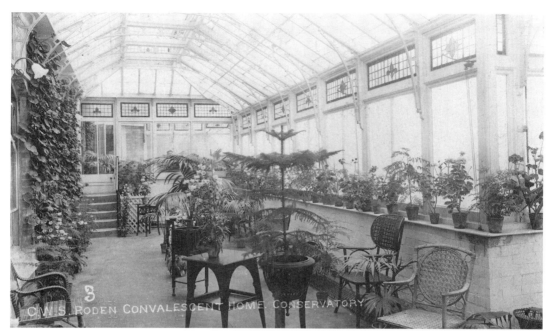

Roden, *c.* 1910. The last person to live at Roden Hall was Alfred Ernest Payne. After it was sold to the society it was developed into a convalescent home, which opened in July 1901, for society workers from Lancashire and Yorkshire recovering from illness. The society also built around twenty houses for the workers and provided many well-paid jobs for local men and women. The lady in the photograph below is the matron of the home, possibly Miss M.J. Twigg, in her private room. Cis writes to her mother in Burnley, 'My word she is a nice person to get on with. I should enjoy it a lot more if it would buck up, (the weather I mean) it is a lovely place.'

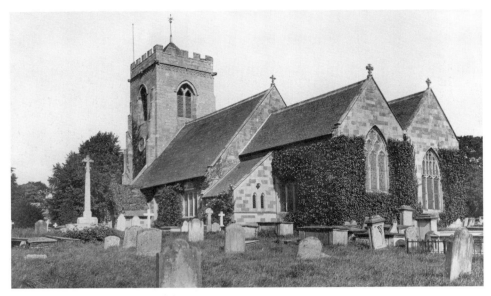

High Ercall, *c. 1925*. *Kelly's Directory* of 1926 states that St Michael's Church was originally dedicated to St Edward the Confessor. There are also two theories about its fate in the Civil War. Local historian the Revd Mr Cranage believed it sustained great damage during the war whereas Nikolaus Pevsner was convinced it had survived virtually intact. Between 1864 and 1865 it was greatly restored by G.E. Street at a cost of around £1,600. Inside the church, built into the north wall, is a Norman tympanum depicting the tree of life and dating from about 1110. The vicar in 1925 was the Revd Arthur Norman Spencer Scott.

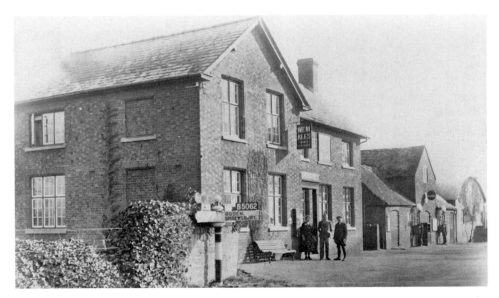

High Ercall, *c. 1935*. The Cleveland Arms Hotel stands opposite the junction to Shrewsbury (note the signpost). In 1896 the hotel belonged to Lord Barnard but was occupied by John Hughes who kept the house clean and in good repair. There were five rooms on each floor and stabling for six horses. It was reported that the stables needed repairing and lime-washing. By the 1930s the landlord was John Randle Roberts, the man on the right, with wife Mary and son Charles. Note the two ancient petrol pumps next door and the sign advertising 'Essotube'.

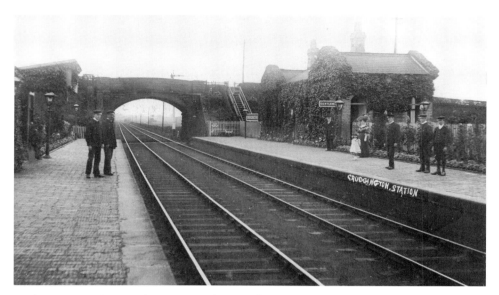

Crudgington, *c.* 1910. Crudgington was the second station on the line from Wellington to Market Drayton that was opened in 1867. It was busy for a small station and used by the Co-operative Wholesale Society, the Newport and District Agricultural Trading Society and two coal merchants; A. Boulton & Co. and the Lilleshall Co. Ltd. A co-operative was set up in the village in 1921 which sent milk to London in the winter and made cheese in the summer. The station closed in 1963. Note the stationmaster in the frock coat standing under the sign. In 1913 the stationmaster was Samuel Harris.

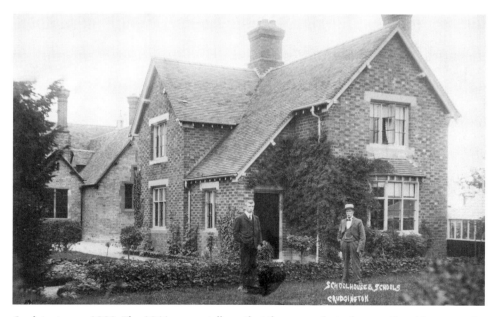

Crudgington, *c.* 1909. The 1841 census tells us that there were forty-three scattered houses and a population of ninety people. The Board School was erected in 1877 to accommodate ninety children. In 1885 the headmaster was John Davies and the average weekly attendance was fifty-eight. Mr Davies was in charge of the school for over twenty years and was succeeded by Edgar Percy Davies. This postcard dated 20 January 1909 shows two men outside the schoolmaster's house. It could possibly show the retiring master and his replacement.

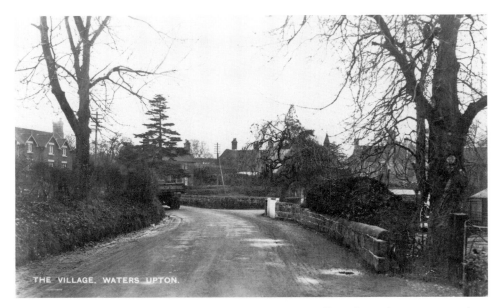

Waters Upton, *c.* 1930. Originally known as Upton Parva, the village changed its name to Walters Upton in honour of the Lord of the Manor, Walter Fitzjohn. By the middle of the thirteenth century it changed again to its present name. Through the trees is the tower of St Michael's Church, which was completely rebuilt by G.E. Street in 1865. In 1930 the village had two doctors' surgeries, two public houses, the Lion and the Swan, two grocery shops, a dressmaker, a motor engineer, a shoemaker and a blacksmith.

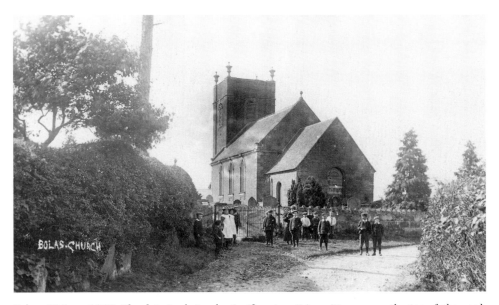

Bolas, 12 June 1912. The date is obviously significant as it is written across the top of the card. Perhaps these children are about to embark on a Sunday school trip or are going to be confirmed. The church is dedicated to St John the Baptist. It was built from red brick and consists of a chancel, nave and west tower. The chancel dates from the seventeenth century but the nave and tower, designed by John Willdigg, were built between 1726 and 1729. Instead of pinnacles, the tower is topped with large stone urns.

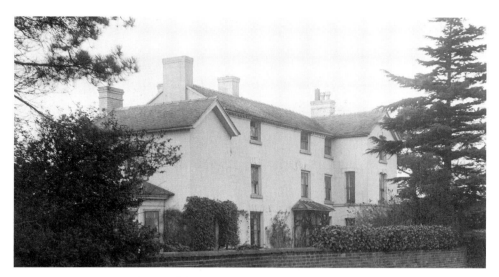

Eaton-on-Tern, *c. 1925*. This small hamlet lies quietly between the busy A41 and A442 just over 3 miles south of Stoke-on-Tern. In *Bagshaw's Directory* for 1851 he refers to it as Eaton-by-Stoke. The name is derived from 'Eaton', meaning a settlement, by the River Tern. In the middle of the 1920s, John Heatley, who lived at the grange, was described as the sole landowner. Most of the inhabitants were farmers but there was a Primitive Methodist chapel and a village shop.

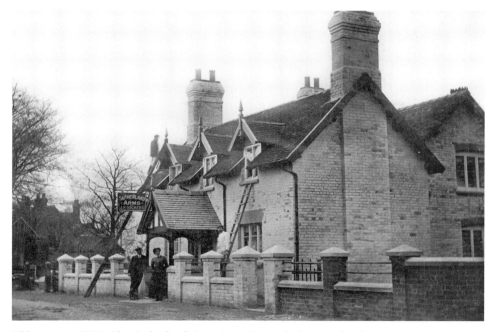

Tibberton, *c. 1910*. The Sutherland Arms is getting a fresh coat of paint, a great improvement on the 1896 census of public houses, when it was reported, 'House and stables require cleaning, lime-washing and repairing.' However, by 1901 we are informed that the premises are 'clean and in good condition.' The owner of the inn was the Duke of Sutherland but the landlady on both occasions was Mrs Esther Ducker. There were three rooms on the ground floor and five upstairs and stabling for four horses. Joseph Ducker became landlord after John Booth. He was followed by his wife and then by his son Henry until about the time of the First World War, when it was taken over by Charles Gamble.

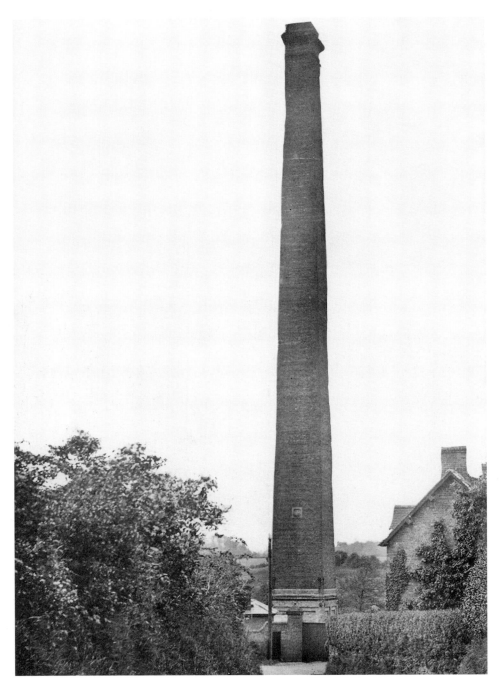

Tibberton, *c.* 1920. The full name for the village is Tibberton-cum-Cherrington. At this period the village was mostly made up of people working on the land but there was a tailor, a carpenter, a Co-operative Industrial Society, a blacksmith, a shoemaker and a large paper mill. The mill was constructed in about 1804 and closed in about 1912, making it the last paper mill in Shropshire. The mill was enlarged in 1860 and this large chimney, which was about 160ft high, was erected in 1874 when the mill was converted from water power to steam. The chimney was demolished in 1932 causing great excitement among the villagers who saw it being razed to the ground.

NORTH OF THE A5

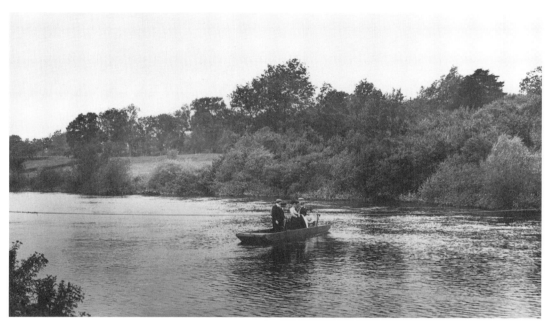

Uffington, *c.* 1905. At the beginning of the twentieth century people used the ferry between Monkmoor and Uffington to ramble and picnic on Haughmond Hill. The ferryman at this time was Allen Davis who lived at Ferry Cottage on the Uffington side near the church. The ferry continued to function until the 1950s, the last ferryman being Will Stevens. Harold Owen, the brother of war poet Wilfred, describes Uffington Ferry as a 'long, flat-bottomed, heavy, punt-like contraption – propelled across the river by the ferryman hauling hand over hand on a light wire hawser that was stretched tautly from one bank to the other. Normally, it was a simple operation, but when the river was running fast with heavy flood water, it needed great skill and long experience to manoeuvre the clumsy craft safely across.'

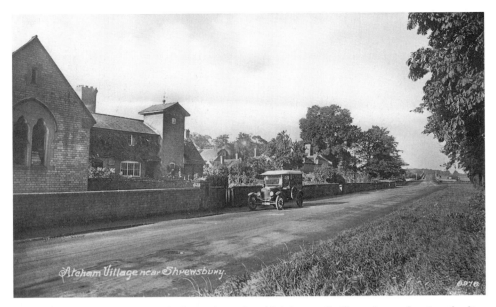

Atcham, *c.* 1925. This view is looking along the old A5 towards Shrewsbury, showing the line over the old bridge. The van, advertising the *Daily Express*, probably belonged to Richard Mansell, a Shrewsbury stationer who published this card. The van is standing outside the post office and grocery shop belonging to Charles Caswell. The school on the left was built with a master's house in 1865. It was enlarged in 1893 to accommodate 120 pupils and had a weekly average attendance in 1905 of eighty children.

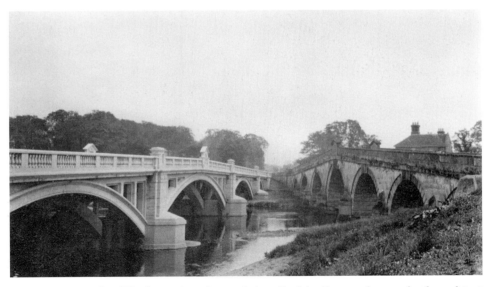

Atcham, *c.* 1930. The old bridge on the right was designed by John Gwynn who was also the architect of the English Bridge in Shrewsbury. It was completed in 1776 at a cost of £7,339 6s 10d. With the increase in volume, speed and weight of vehicles on the road in the 1920s, Atcham Bridge was considered one of the most dangerous over the Severn. The new bridge was built upstream of the old one at an angle of 66 degrees. It was opened on 24 October 1929 by Herbert Morrison MP, the Minister of Transport. The main contractor was Grey's Ferro-Concrete Co. of Glasgow and the cost was about £58,966.

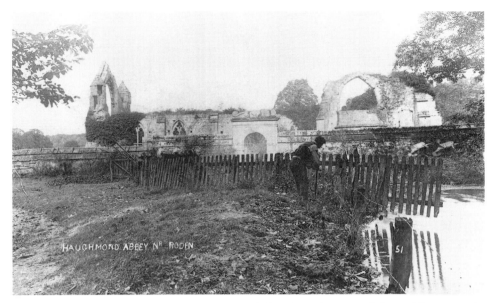

Haughmond Abbey, *c.* 1905. The abbey was founded in the early years of the twelfth century by William Fitz Alan for Augustinian monks. During the reign of Henry II, the king's old tutor Alfred was made abbot. The abbey was dissolved in September 1539 when the Abbot Thomas Corveser received a pension of £40 and the ten canons a pension of between £5 and £6. A great deal of the abbey was demolished but part was converted into a dwelling by the Littleton family who bought the site. The abbey is now in the care of English Heritage.

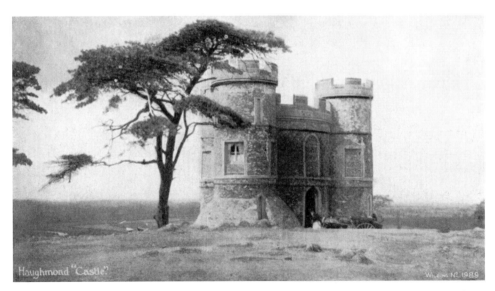

Haughmond Hill, *c.* 1905. The castle was a folly built by John Corbet as a hunting lodge in about 1770. It was also used to fly a flag to warn people in the area that he had returned from Warwickshire with his pack of hounds and would be hunting the next day. The lodge was occupied for several years by the local rat catcher. It was also the focal point for visitors to the hill, especially on Bank Holidays, when families would walk along the old canal from Shrewsbury or cross the Severn at Uffington to enjoy a picnic on the hill. Unfortunately the castle was vandalised, before falling into decay and collapsing in 1931.

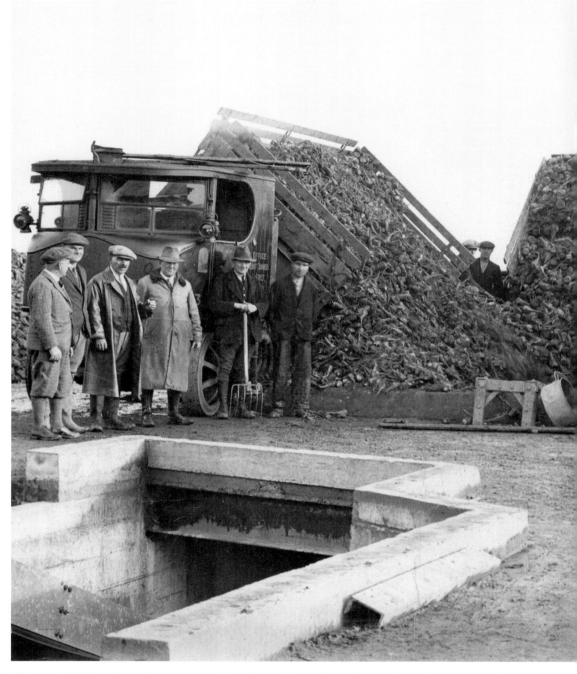

Allscott, *c.* 1927. Two Sentinel steam wagons deliver loads of sugar beet to the new factory that was opened in 1927. Shropshire became the largest grower of sugar beet in this area of the country and in 1934 most of the crop was grown within 15–25 miles of the factory. That year the factory processed 177,592 tons of beet but by 1965 that had grown to 249,225 tons. The factory closed at the beginning of the new millennium and was demolished. The steam wagons belonged to S.J. Hayward & Co. (haulage) Ltd, whose main office in Shrewsbury was in Talbot Chambers, Market Street.

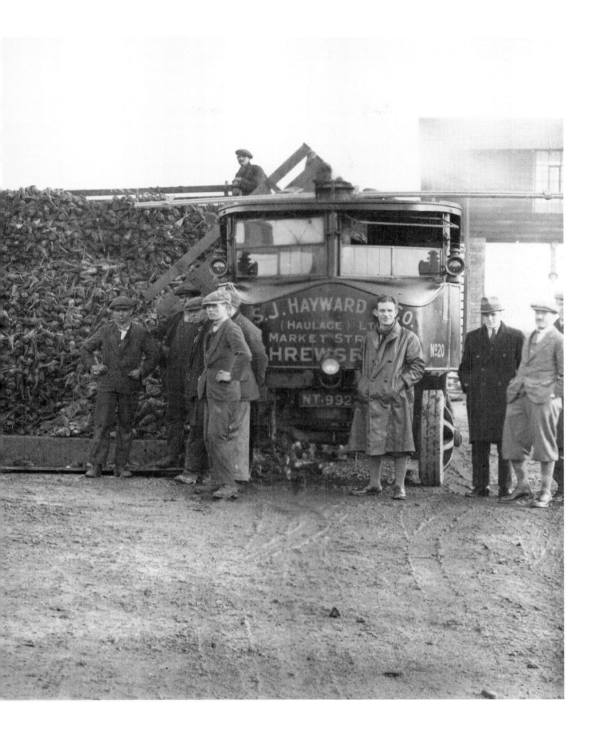

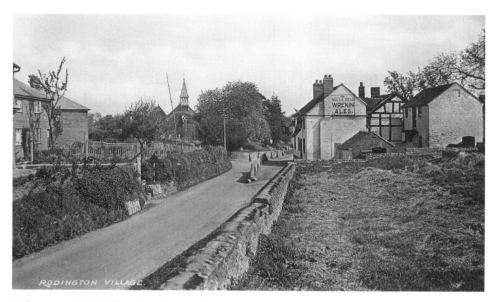

Rodington, *c.* 1930. The village lies 7 miles east of Shrewsbury on the banks of the River Roden and the Shrewsbury branch of the disused Shropshire Union Canal. The Bull's Head Inn on the right is reputed to be one of the oldest inns in the county and in the nineteenth century was a centre for bull-baiting and cockfighting. By 1896 it was owned and occupied by Mary Allen whose family had run the inn from the 1870s. By 1901 the inn had been sold to Richard Broome, who owned the Oak Inn at Cantlop and employed George Charles Phillips as manager. From about 1905 until the late 1930s the Bland family were the hosts at the inn.

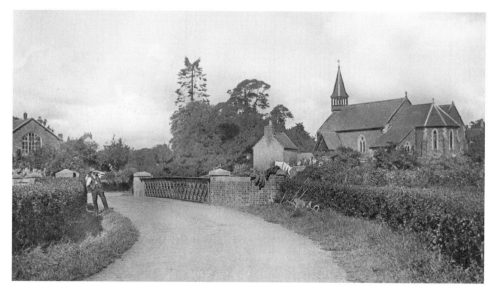

Rodington, *c.* 1930. A church and a priest in the village were recorded in the Domesday Book. The church was replaced by a Georgian structure in 1751, which in turn gave way to this Victorian church. It is dedicated to St George and was built of brick in the Early English style in 1851. It consisted of an apsidal chancel, nave, north aisle, south porch and a short wooden turret and spire. During renovation a section of the old medieval wall was uncovered towards the west end of the church in 1929. In 1930 the village had a new vicar, the Revd Benjamin Moray McOwan.

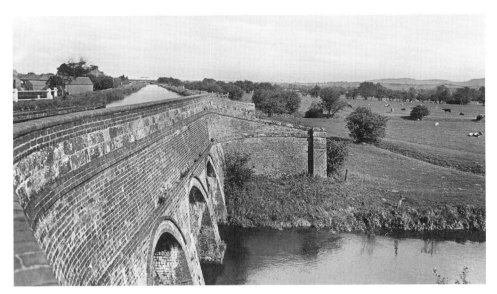

Rodington, *c.* 1930. This is a view of the Shrewsbury branch of the Shropshire Union Canal before it was drained. The bridge, complete with a towpath on the opposite bank, is an early example of a canal aqueduct. It had three solid arches and carried the canal over the River Roden. In the distance is one of several drawbridges; unfortunately both bridges were demolished. Rodington also had its own wharf opposite Rodington House for loading and unloading goods.

Longdon-upon-Tern, *c.* 1920. The name of the village is derived from the long hill by the River Tern. In the nineteenth century it was described as 'scattered but pleasantly situated on elevated ground on the southern banks of the river, and commands many interesting views of rural beauty.' This is the B5063 leading to High Ercall while the turn to the left is a minor road leading to Rodington and Sugdon, which is miss-spelt Sugden on the signpost. The men are standing outside the village forge. The blacksmith in 1920 was William Ralphs; he was succeeded by George Ralphs, who continued the trade into the middle of the twentieth century.

Longdon-upon-Tern, *c.* 1925. This wooden shed next to a cottage and the roadside was the village stores. Until the 1920s no shop is listed in any of the *Kelly's Directories*. In 1929 Mrs Harriet Nevols & Son are listed as grocers. Both windows look well stocked with groceries and Lyons' Tea is advertised under the left window. They also sold newspapers with the *Daily Mirror* advertising £11,000 in prizes, while another's banner headline is '30 Mile Earthquake In England'. William Nevols is also listed in the directory as a motorcycle and cycle dealer. By 1941 the shop is listed as H. & O. Nevols grocers and cycle and motor accessories dealers.

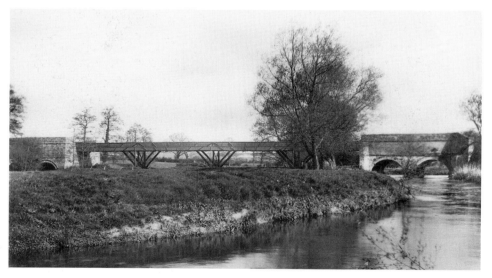

Longdon-upon-Tern, *c.* 1930. The Shrewsbury branch of the Shropshire Union Canal was opened in 1796. This aqueduct built at Longdon to take the canal over the River Tern is quite unique. The centre section is a trough made up of iron sections bolted together and supplied by ironmaster William Reynolds. It was supported on each side by brick abutments. It also had a towpath alongside. It was designed by Thomas Telford and was thought to be the first iron-built aqueduct to have been constructed. It is about 180ft long and 15ft high and was opened to barges on 14 March 1796.

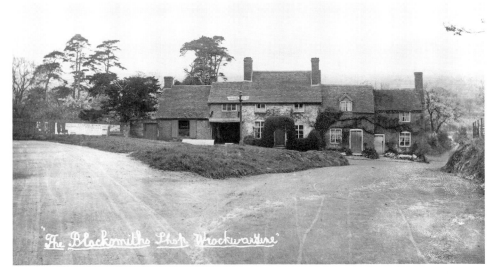

Wrockwardine, *c*. 1905. The blacksmith's shop, situated at a crossroads, was worked by Samuel Williams in 1905. He took the business over from Mrs Margaret Julia Houlston who ran it for several years after the death of her husband Barzillia. The Houlstons appear to have lived in the village for several centuries. In 1851 Bagshaw lists Charles Houlston as a blacksmith and agricultural implement maker, John Houlston as a shoemaker, Josiah Houlston as a farmer, Joshua Houlston as an assistant overseer and vestry clerk and Thomas Houlston as a farmer, assessed tax collector and parish clerk – a post the family had held for over 257 years. The poster to the left advertises a 'Great Drapery Sale' at Capsey's store in Wellington.

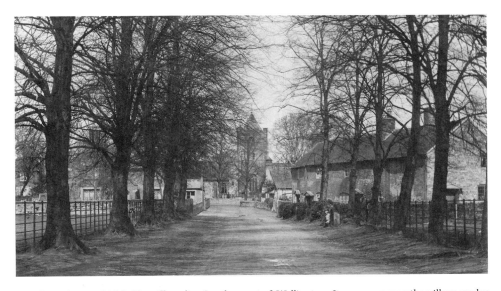

Wrockwardine, *c*. 1905. The village lies 2 miles west of Wellington. Its name means the village under the Wrekin, which lies to the south. This view down The Avenue, leads to St Peter's Church. The building is mainly Early English in style but there are sections from the Norman, Perpendicular and Decorated periods. The church is cruciform with a chancel with chapels on either side, a nave, north and south transepts, and a central tower. Building took place between 1881 and 1891 at a cost of around £1,250. The school on the left with a house for the master and mistress was erected for boys in 1837 and extended for girls and infants in 1853. It was enlarged in 1885 to accommodate 110 children.

ACKNOWLEDGEMENTS

M y thanks go once again to the staff of the Shropshire Records and Research Centre. It is nice to work in such a welcoming environment where the people are always friendly and helpful. I am also grateful to Toby Neal, the Nostalgia Editor of the *Shropshire Star*, whose articles are always informative, provoking interesting replies from the readers that have shed a great deal of light on the local history of Shropshire. I would also like to acknowledge with thanks the information I have gained from other local authors, whose books are listed in the bibliography.

BIBLIOGRAPHY

Barton, J., *A Millennium History of Whitchurch*, 2001
Hitches., M. & Roberts, J., *Shropshire Railways*, Sutton Publishing Ltd, 1996
Jackson, M., *Castles of Shropshire*, Shropshire Libraries, 1988
Kelly's Directories of Shropshire (various dates)
Leonard, J., *Churches of Shropshire*, Logaston Press, 2004
Mercer, E., *English Architecture to 1900*, Logaston Press, 2003
Mitchell, V. & Smith, K., *Branch Line to Shrewsbury*, Middleton Press, 1991
Moran, M., *Vernacular Buildings of Whitchurch*, Logaston Press, 1999
Morris, M., *Whitchurch to Market Drayton in Old Photographs*, Sutton Publishing, 1994
Neal, T., *Shropshire Since 1900*, Langrish Caiger Publications, 2007
Nicolle, D., *Market Drayton*, WHS, 2001
Oppitz, L., *Lost Railways of Shropshire*, Countryside Books, 2004
Pevsner, N., *Shropshire*, Penguin Books, (reprint) 1989
Prentice, R., *A History of Newport*, Phillimore, 1986
Pybus, K. & Dickins, G., *Market Drayton Then & Now*, K. & M. Pybus, 1995
Raven, M., *Shropshire Gazetteer*, Michael Raven, 1989
Salter, M., *Parish Churches of Shropshire*, Folly Publications, 1988
Shrewsbury Chronicle (various dates)
Trinder, B., *The Industrial Archaeology of Shropshire*, Phillimore, 1996
Whitchurch Archaeological Group, *Whitchurch Remembered*, 1979
Whitchurch Archaeological Group, *Whitchurch Remembered*, 2000
Willan, C.H., *1000 Years in the History of Newport*, Newport Books, 1979